the photographer's
guide to Cape Cod
& the Islands

Where to Find Perfect Shots and How to Take Them

Chris Linder

THE COUNTRYMAN PRESS
WOODSTOCK, VERMONT

ISBN-13: 978-0-88150-767-6

Cover photograph of Sankaty Head Light, Nantucket Island,
and interior photographs by the author
Cover and interior design and composition by Susan Livingston
Maps by Paul Woodward, © The Countryman Press

Published by The Countryman Press, P.O. Box 748, Woodstock, VT 05091
Distributed by W.W. Norton & Company, Inc., 500 Fifth Avenue, New York, NY 10110

Printed in China by R. R. Donnelley

10 9 8 7 6 5 4 3 2 1

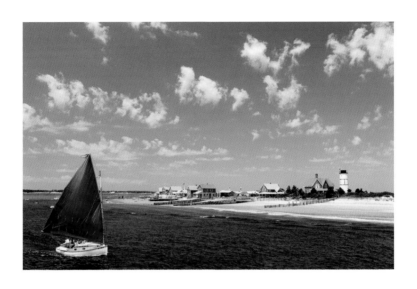

Dedicated to my wife;
it's always magic light when we're together.

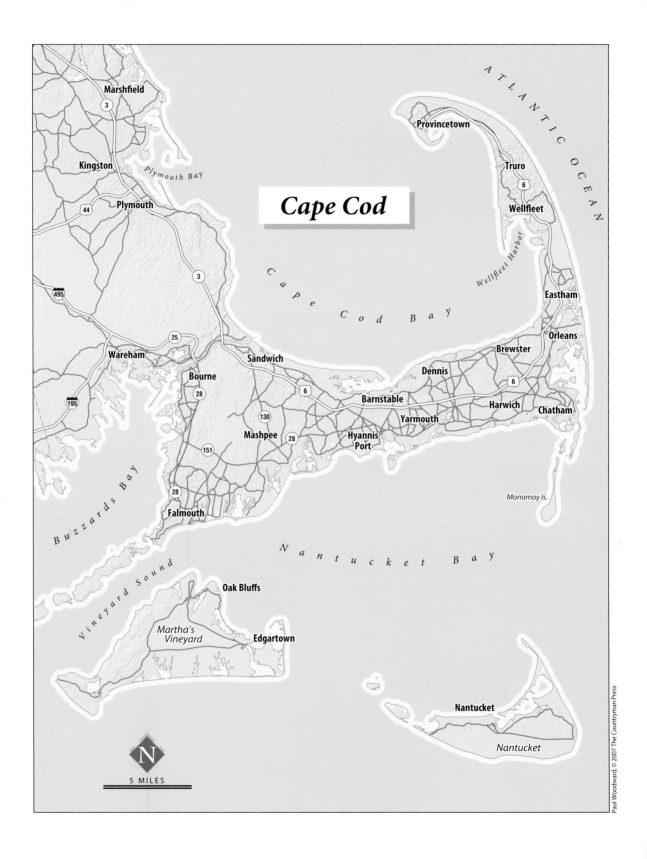

Cape Cod

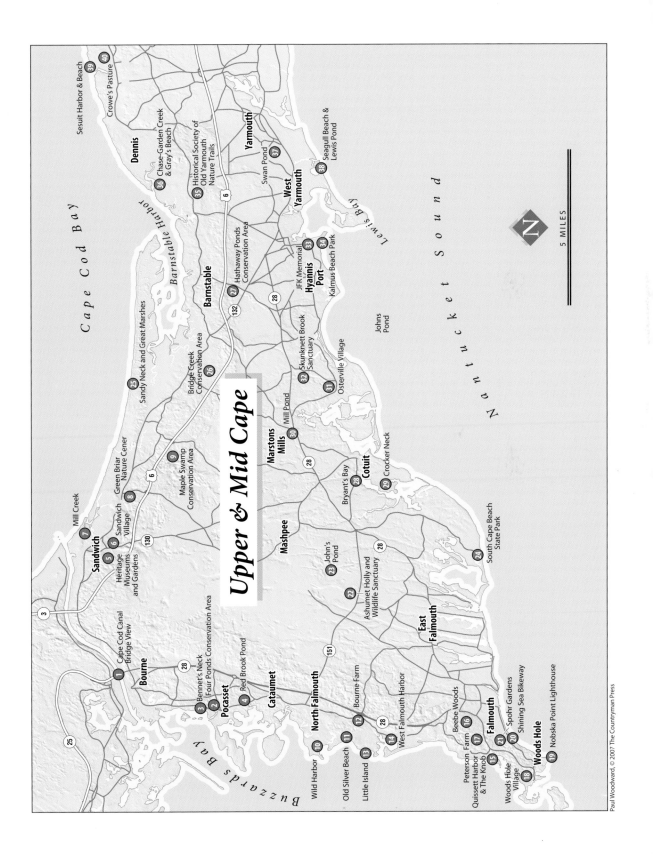

Upper & Mid Cape

Cape Cod Bay

Buzzards Bay

Barnstable Harbor

Lewis Bay

Nantucket Sound

Bourne
Sandwich
Pocasset
Cataumet
North Falmouth
East Falmouth
Falmouth
Woods Hole
Mashpee
Marstons Mills
Cotuit
Barnstable
Hyannis Port
West Yarmouth
Yarmouth
Dennis

Crowe's Pasture
Sesuit Harbor & Beach
Chase-Garden Creek & Gray's Beach
Historical Society of Old Yarmouth Nature Trails
Seagull Beach & Lewis Pond
Swan Pond
Hathaway Ponds Conservation Area
JFK Memorial
Kalmus Beach Park
Skunknett Brook Sanctuary
Osterville Village
Johns Pond
Sandy Neck and Great Marshes
Bridge Creek Conservation Area
Green Briar Nature Cener
Maple Swamp Conservation Area
Mill Creek
Heritage Museums and Gardens
Sandwich Village
Mill Pond
Crocker Neck
Bryant's Bay
South Cape Beach State Park
John's Pond
Ashumet Holly and Wildlife Sanctuary
Cape Cod Canal Bridge View
Bennet's Neck
Four Ponds Conservation Area
Red Brook Pond
Bourne Farm
West Falmouth Harbor
Wild Harbor
Old Silver Beach
Little Island
Beebe Woods
Peterson Farm
Quissett Harbor & The Knob
Woods Hole Village
Spohr Gardens
Shining Sea Bikeway
Nobska Point Lighthouse

N

5 MILES

Paul Woodward, © 2007 The Countryman Press

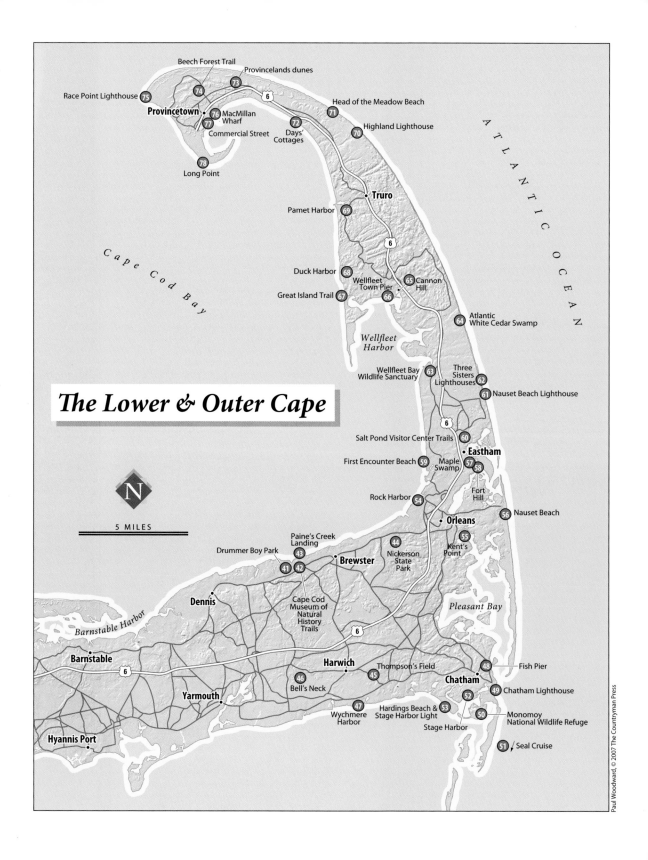

The Lower & Outer Cape

N

5 MILES

Beech Forest Trail
Provincelands dunes
Race Point Lighthouse 75
74
73
6
Head of the Meadow Beach
76 MacMillan Wharf
Provincetown
77
Commercial Street
72 Days' Cottages
71
Highland Lighthouse
70
78
Long Point

Cape Cod Bay

ATLANTIC OCEAN

Truro
Pamet Harbor 69
6

Duck Harbor 68
Wellfleet Town Pier
65 Cannon Hill
Great Island Trail 67
66
64 Atlantic White Cedar Swamp

Wellfleet Harbor

Wellfleet Bay Wildlife Sanctuary 63
Three Sisters Lighthouses 62
61 Nauset Beach Lighthouse
6
Salt Pond Visitor Center Trails
60
First Encounter Beach 59
Maple Swamp
Eastham
57 58
Fort Hill
Rock Harbor 54
56 Nauset Beach
Orleans
55 Kent's Point
44 Nickerson State Park
Paine's Creek Landing
Drummer Boy Park
43
41 42 Brewster
Pleasant Bay

Dennis
Cape Cod Museum of Natural History Trails

Barnstable Harbor

6

Barnstable
Harwich
Thompson's Field
48 Fish Pier
45
Chatham
49 Chatham Lighthouse
6
46 Bell's Neck
52
Yarmouth
47
Hardings Beach & Stage Harbor Light
53
50 Monomoy National Wildlife Refuge
Wychmere Harbor
Stage Harbor
Hyannis Port
51 Seal Cruise

Paul Woodward, © 2007 The Countryman Press

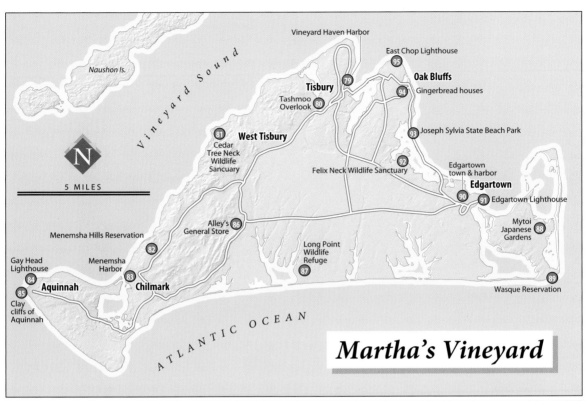

Naushon Is.

Vineyard Sound

Vineyard Haven Harbor

East Chop Lighthouse
95

Oak Bluffs
94
Gingerbread houses

79

Tisbury
Tashmoo
Overlook **80**

93 Joseph Sylvia State Beach Park

81
Cedar
Tree Neck
Wildlife
Sanctuary

West Tisbury

92

Felix Neck Wildlife Sanctuary

Edgartown
town & harbor

Edgartown
90 **91** Edgartown Lighthouse

N

5 MILES

Alley's
General Store **86**

Menemsha Hills Reservation

82

Long Point
Wildlife
Refuge
87

Mytoi
Japanese
Gardens **88**

Gay Head
Lighthouse
84

Menemsha
Harbor **83**

Aquinnah

Chilmark

85
Clay
cliffs of
Aquinnah

ATLANTIC OCEAN

Wasque Reservation
89

Martha's Vineyard

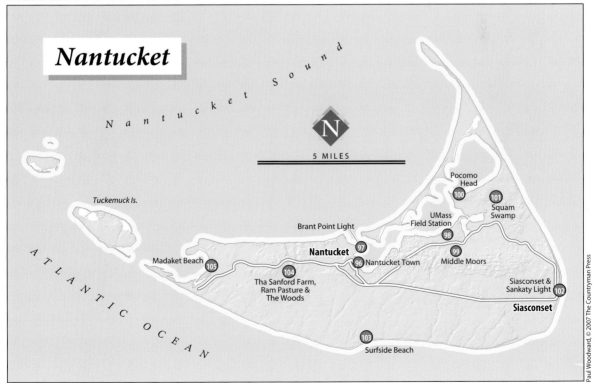

Nantucket

Nantucket Sound

N

5 MILES

Tuckemuck Is.

Pocomo
Head

100

101
Squam
Swamp

UMass
Field Station

Brant Point Light

98

Nantucket
97

96 Nantucket Town

99
Middle Moors

Madaket Beach **105**

104

Tha Sanford Farm,
Ram Pasture &
The Woods

Siasconset &
Sankaty Light
102

Siasconset

ATLANTIC OCEAN

103
Surfside Beach

Paul Woodward, © 2007 The Countryman Press

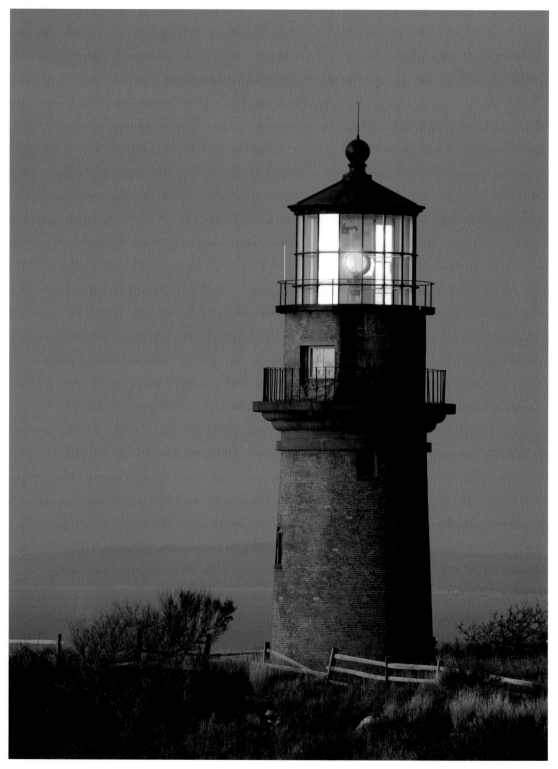

Gay Head Lighthouse, Martha's Vineyard

Contents

The Islands

Introduction

Cape Cod and the islands of Martha's Vineyard and Nantucket are dominated by the sea, although perhaps it is more accurate to say *seas*. Each side of this long, curved peninsula is influenced by its own body of water—Buzzards Bay to the west, Cape Cod Bay to the north, Vineyard and Nantucket Sounds to the south, and the open waters of the Atlantic Ocean to the east. Few places in the United States have so many oceans in their backyard. The water brings a wealth of photographic subjects, from acrobatic humpback whales in Cape Cod Bay to colorful dinghies in hidden harbors. Where the water meets the land, there are beaches, as varied as the bodies of water they abut. Many are broad swaths of sand, some are rock cobble, and others are steep dramatic cliffs.

For the typical summer weekend visitor, it's easy to fall into the trap of believing the Cape and Islands are one long beach punctuated by lighthouses and sailboats. In addition to these familiar maritime subjects, there is hidden beauty waiting to be discovered on paths less traveled. Leafy lanes lead to old stone walls and grist mills, remnants of the Cape's colonial history. Fragile orchids and prolific ferns grace the upland forests in springtime. Herons and egrets hunt bullfrogs and minnows along the margins of fog-shrouded ponds. In short, the photographic opportunities are practically endless—if you take the time and know where to look.

The scenic beauty of the Cape and Islands makes it easy for anyone to come home with respectable snapshots. Those seeking truly memorable images, however, will need to work a bit harder. Inspiring photographs don't just happen; they are the result of creative vision applied to the right subject at the perfect time.

Kayaks, Provincetown

This requires knowing where to set up your tripod when the light is just right. Sounds like a drag, doesn't it? It's hard to believe that making a piece of art has anything to do with research—location scouting, tide tables, sunrise and sunset times, and weather forecasts.

This guidebook has been a labor of love for me. I have spent years driving the roads, hiking the trails, walking the beaches, and watching the light—in essence, doing the homework for you: figuring out when to be where and what subjects to look for. There is still the matter of setting your alarm clock, getting to the location, and being creative. But that's up to you.

Tashmoo Overlook, Martha's Vineyard

Using This Book

This book is the first guide to Cape Cod and the Islands written by a photographer specifically for photographers. Frankly, photographers think differently from other people, asking themselves specific questions about the places they visit: What will the light be like here at sunrise? Are there any subjects in the area that would be photogenic at midday? Where is the best place to photograph during a light rain? In the end, I evaluated each location in this guide with a tough criterion in mind: does this location have unique photographic potential?

Once a location passed the unique test, I considered the lighting and seasonal factors. Finally, I also ensured that each site is easily accessible to the general public; no site requires an off-road vehicle or private landowner's permission. The end result is a compilation of the best photo-worthy spots on the Cape and Islands. For each of the location chapters, I have rated the seasonal potential on a scale of one to four stars (four being best). In addition to a description of the location and photo subjects, I provide directions so you can find those out-of-the-way spots. You should consider a detailed map a critical supplement to this guide.

This book isn't just about finding hidden spots (in reality there are few of those left on the Cape and Islands)—it's also about new ways to look at iconic spots. For example, I suggest what subject might look best just after sunset, or where a vantage point of lying on your belly might reveal an interesting composition. These suggestions, which I dub "Pro Tips," are sprinkled throughout the location descriptions and also appear at the end of each chapter. I also include "Cautions." These are things to avoid, like getting hit by nor'easter waves or eaten alive by sand flies. Finally, I also suggest some diversions. On some days, the weather tells you "keep the camera in the bag." Instead of forcing a bunch of terrible shots and wasting your time, sometimes it is more productive to take a day off and walk around a museum or art gallery. Who knows, you may even find some inspiration that makes the next day an even better one.

The final chapter is a listing of my favorite places. As the name implies, these are personal choices and as such are entirely subjective. These sites are grouped by subject, such as "harbors" and "sunset spots." Try keeping a list of your own favorites—when the light is perfect, it makes deciding where to set up the tripod that much easier.

Most importantly, I hope you use this guide to get out there and see more of the Cape and Islands, in particular the green conservation areas that many of the townships have set aside for public use. They are seldom plagued by crowds and often yield surprising shots.

How I Photograph the Cape and Islands

When I pack up my gear and head out to shoot, a million things are swirling through my mind. What subject am I expecting to find? How is the light going to be in a half hour? What lens should I use? Ultimately, the answers to these questions are always different. Photography, to me, is about expressing creativity. You might expect this section to be a series of answers—this is the best light, this is the best lens. Consider, instead, that this section is more of a way to ask the right questions when preparing to go on a shoot.

Before we launch into technical jargon, keep in the back of your mind that your subject must inspire you. The most important element in any image is your vision and the message you are trying to convey. Are you trying to show the fragility of a tiny starflower in the forest? Perhaps you are capturing the smile of a child seeing the ocean for the first time. Whatever it is, to make a successful photograph of your subject you must convey to others your excitement in seeing it. Without this spark, how can you expect your viewer to enjoy looking at your photograph? Once I find a subject that inspires me, it's time to assess how I can capture it on film or memory card in the most aesthetically pleasing way.

Light and Weather

My primary concern is the light. It is a critical ingredient in photography since cameras record the light reflected off their subjects. Good light can transform mundane subjects into works of art. Conversely, bad light can be a death knell for the most promising scene. Learning to read the light takes practice and experience. The following basic guidelines will help you develop your light instinct.

Golden hours: The brief time just after sunrise and before sunset produces a warm, angular light that you just can't find at noontime. The drawback: you need to wake up early to catch sunrise. In June that can mean setting the alarm before 4 AM. In autumn, sunrise and sunset often coincide with mealtimes, making it that much harder to get outside with your camera. If you are determined to catch the best light, noon naps and energy bars will be your best friends.

Pre-dawn and twilight: These are my absolute favorite times of day to shoot, in particular buildings that are lit with floodlights like churches and historic homes. About 30–40 minutes before the sun comes up (or after the sun goes down), regardless of weather conditions, the sky turns a beautiful midnight blue. For a few magic minutes, floodlit buildings are exactly the same brightness as the sky. This means that the entire frame will fall within the contrast limits of your film or digital sensor. The result is a colorful, punchy shot. The drawback here is that this light only lasts about 10 to 20 minutes, meaning you realistically can work only one subject.

Weather: Light and weather are close partners, with the second often controlling the first. It can be friend or foe, depending on your subject. Dark, towering storm clouds enhance a landscape, but a blanket of dull white stratus clouds can smother it. Similarly, bright sun in a forest creates a contrast nightmare, while a thick mist can give the same forest a dreamy transcendence. The key is matching weather and subject. If the weather changes suddenly, try photographing something else. The great news here is that the Cape is relatively small.

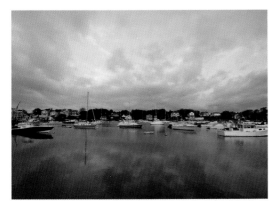 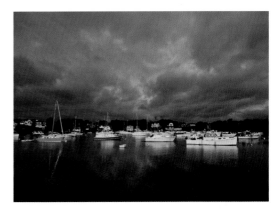

At left is an example of flat light; at right, dynamic light. Both photos were taken two minutes apart.

No matter where you are, it will likely only take 15 minutes to go from a town square to a beach or a small wooded conservation land.

Breaking Down Creative Walls

Look first, shoot second: I'm sure you know the feeling. You show up at the perfect location just before sunset. You jump out of the car, set up the tripod, and start shooting. After the light has faded, while packing up your gear, you notice a nice rock formation about 50 yards away that would have made the perfect foreground—but now it's too late. Even though it's hard to resist the excitement of getting started right away, instead first wander around the location, scouting out the best possible vantage point or subject. Next, explore all the possible angles and perspectives, using an imaginary rectangle to frame up compositions. Finally, get out the tripod, set it up exactly where you want, and take the shot.

Learn (and love) your subject: Writing about the sites in this book took years of careful research. In buying this book you have taken the first step to learning about the Cape and Islands and their photo opportunities. However, with the limited space of this format, there is no way I can go into depth on any one sub-

ject. If you are really interested in getting a photo of kayakers paddling through a salt marsh at sunrise, or gray seals hauled out at Monomoy National Wildlife Refuge, it pays to do some extra research. Talk to shop owners, park rangers, and locals. They have always been extremely eager to help me in my research, and you would be amazed how much this extra knowledge of your subject can help your photography.

Change your point of view: The position of your camera in relation to the position of your subject tends either to emphasize its importance (if you're looking up at your subject) or to de-emphasize it (if you're looking down on your subject). When photographing wildlife or small subjects like wildflowers, I often shoot from their eye level, so to speak. This often involves getting low, sometimes putting the camera directly on the ground.

Experiment and play: Sometimes you need to let your inner child out to play. If you are shooting digitally, it doesn't cost anything to try something truly bizarre. For example, try a multi-second exposure while walking through a forest at the peak of fall foliage. The resulting impressionistic photograph may reveal a totally new way of seeing the world.

Use your LCD monitor: For those with digital equipment, this may seem obvious, but the instant gratification of seeing your photo on the LCD screen is the single greatest advantage of a digital camera. I can't tell you how many times I have framed up a perfect shot, then reviewed it on the monitor and found an offending twig or power line peeking into a corner. I review almost every shot I take, and 90 percent of the time I can find a way to improve my composition as a result.

Mix up your lens selection: Have you ever tried shooting a frog with a 24mm lens? How about sand dunes with a 400mm? Altering the perspective of your shot by changing your distance to the subject and using a different focal length is a way to diversify your images.

Get off your feet: Consider bringing or renting some alternate transportation to mix up your shots. The view from a kayak is a lot different from the one on shore. Extensive bike trails on both the Cape and Islands also encourage you to slow down, notice more, and avoid traffic. Plus, the exercise is an added bonus.

Essential Equipment

Photographing the Cape and Islands doesn't require any specialized equipment, but the following tools are always with me:

Sturdy tripod: Unless I'm shooting fast-paced action or I'm on a pitching boat, I always carry a sturdy tripod. A tripod will improve the sharpness of your shots, period. It also allows you to stop down the aperture and use a larger depth of field. A tripod is particularly essential when using a close-up or telephoto lens, since even the smallest vibrations will be magnified. Finally, a tripod will force you to slow down and be more deliberate in your compositions. If I can't bring my tripod, I do my best to make an improvised tripod by bracing the camera on something sturdy like a lamppost or a wall.

Filters: As a personal choice, I avoid filters with two exceptions. The first is a polarizing filter. The "polarizer" eliminates reflections, cuts haze, and intensifies blue skies. It is simple to use—if you're using a single-lens-reflex camera or a digital camera with a live monitor simply rotate the front ring to see the effects vary in intensity. While many folks use this filter only on bright sunny days to make skies bluer, I generally use mine when it's wet out or I'm photographing water. This is because the polarizer eliminates reflections on wet or shiny surfaces, giving you more saturated colors. Try using a polarizer when shooting fall foliage after a light rain and you'll see what I mean. But don't forget to carry a tripod, because a polarizer robs you of two to three stops of light.

Distracting power lines ruin this image.

A change of position fixes the problem.

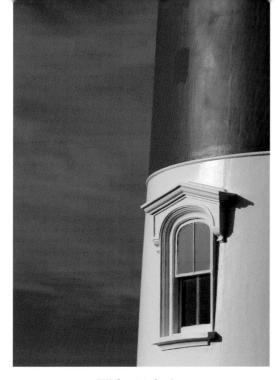
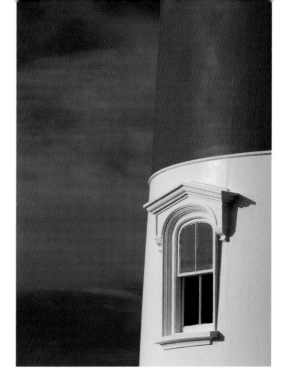

Without polarizer *With polarizer*

The other filter in my kit is the split-graduated neutral density filter, also known as a "split-grad." This ingeniously simple device is clear on one half and a dark neutral gray on the other. It is commonly used to balance the contrast when you have a bright sky and dark foreground. Split-grads come in a variety of strengths and have either abrupt or gradual transitions between the dark and clear areas. I primarily use a 3-stop flavor with a soft transition. Digital photography is no exception—although there are ways to simulate a split-grad using digital image processing software, I still prefer to balance the exposure as much as possible at the time of capture.

Cape Cod Specialties

Sunrises and sunsets: The Cape is one of those unique spots in the United States where you can photograph sunrise and sunset over ocean waves in the same day. Throw into the mix a wide variety of subject matter, from lighthouses to sailboats, and you have all the ingredients for some rewarding edge-of-the-day shooting.

Boats and fishing gear: Fishing is a way of life for many Cape Codders. Chatham, Provincetown, and Menemsha have large, picturesque working fishing harbors. Some fishermen in Chatham use weirs, a traditional method of catching fish dating back to pre-colonial days. In addition, because of the cold, clear water and vigorous tidal cycle, several shellfish species are farm-raised at many "grants" (underwater farm plots) in Cape Cod Bay and Vineyard Sound. You will sometimes see the farmers' equipment, orderly rows of cages, revealed at low tide. Lastly, colorful boats, buoys, and lobster traps all make worthy photo subjects.

Marine life: Stellwagen Bank National Marine Sanctuary is a shallow 842-square-mile area of

seawater at the entrance of Massachusetts Bay off the tip of Provincetown. The World Wildlife Fund has named it one of the top ten whale-watching sites in the world. Tours leave from West Barnstable on the Mid-Cape and Provincetown on the Outer Cape. The peak season is from early summer to early fall, when the humpback whales are most active. If you're lucky you may also see dolphins, ocean sunfish, or a basking shark. In Chatham, you can take shorter (1–2 hour) trips to see the seals that bask on the southern tip of South Monomoy Island (see the seal-cruise location in the Chatham and Orleans chapter for more information). The boats are much smaller than the whale-watching ships, resulting in a much more intimate experience. The naturalists on-board also point out the rich variety of sea birds that can be seen off Monomoy.

Experiment and play

Wildflowers: You probably don't think of wildflowers when you think of Cape Cod, but this is one of my favorite spring and summer flora spots in New England. You can find a rich variety on display from mid-April through September. In early spring, visit wooded areas to photograph tiny mayflowers and starflowers peeking up from the leaf litter. In May if you look closely you can find delicate pink lady's slipper orchids, an endangered flower that should never be picked. In June and July beach rose and beach pea bloom along the shore. In late summer, visit meadows to find brilliant swaths of goldenrod blooms and insect life.

Hazards

Sand: Beaches dominate the Cape and Islands landscape, so sand is never far away. Never walk away from your tripod at the beach, since a sudden breeze can send your equipment crashing down. Minute particles of sand will work their way into tripod leg joints and camera bodies—a costly repair bill. Blowing sand can also be hazardous to your lenses since the sharp grains may scratch or make small dents (pits) in the lens surface. Using your lens hood, or shade, will help to keep grit off your glass.

Salt spray: Salt corrodes metal and electronic equipment, so take care when photographing in windy conditions near the ocean. Pay attention to the direction of the wind. If the wind is behind you as you face the waves, you are a lot safer than if it is blowing straight towards you from the sea. You may not even feel the spray—check the front of your lens periodically to see if droplets are accumulating. If you are after spectacular crashing wave shots during a nor'easter storm, one option is to switch to a longer lens and back up from the water. Not only will it save your gear from becoming drenched in salt spray, it will also save you from being engulfed by the surging waves. I fre-

quently use a protective filter when photographing in windy conditions near the coast. Replacing a scratched filter is a lot cheaper than replacing a lens. After a day near salt, wipe your gear down with a moist cloth.

Poison ivy: Poison ivy is ubiquitous on the Cape and Islands. The oil from its leaves can cause a mild to severe allergic skin reaction, depending on your tolerance. You can identify it from its shiny green to reddish leaves, which form in groups of three. A helpful mnemonic is "leaves of three, let them be." When using my previous advice to "get down low" to photograph flowers and small critters, make sure you don't lie down in a patch of poison ivy. To minimize the itchy effects of an encounter, wash your hands and clothing thoroughly with soap and water immediately after making contact.

Ticks: These tiny arachnids are the Cape and Islands' most notorious pests. From April through September, you can expect to encounter these bloodsuckers in profusion if you walk near grassy beach areas (i.e., 99 percent of the Cape and Islands). The two most common types of ticks you will find hitchhiking on your clothing or skin are the American dog tick and the deer tick. Both are annoying, but the sesame-seed-sized deer tick is far more dangerous since it can carry the bacteria that cause Lyme disease. The best protection against ticks is to wear light-colored long pants when walking through tall grasses and perform a thorough "tick check" of your clothing and exposed skin after the hike. If a tick bite becomes reddened, seek medical attention for the proper antibiotics to prevent and treat Lyme.

Biting insects: Biting insects, including deer flies, greenhead flies, mosquitoes, and sand flies, arrive at the start of the tourist season, Memorial Day weekend. One of my most humorous photographic foibles on the Cape was an attempt to photograph the Atlantic white cedar swamp in Wellfleet on a calm morning in June. Nothing sucks out the creative juices quite like an armada of thirsty mosquitoes and deer flies. In that particular case I think they also sucked out about a pint of blood before I stumbled, cursing and swatting, back to the safety of my car (this is despite strong insect repellent). Recently, West Nile virus and eastern equine encephalitis, both potentially deadly viral diseases, have been reported in southeastern Massachusetts. Since mosquitoes transmit these diseases, use a strong repellent (with a high percentage of DEET) and wear layered clothing that covers exposed skin. The equally nasty sand fly, also called a midge or "no-see-um," is the beach equivalent of the mosquito. They appear in swarms at sunrise and sunset, and can form in clouds so thick that you have to be careful when changing lenses. One final caution—keep the repellent away from your photography equipment since it eats away at plastic.

Traffic and parking: Like biting insects, traffic peaks in the summer, between Memorial Day and Labor Day. Unlike biting flies, DEET has no effect on traffic. Your best road-rage repellent is a copy of the big spiral-bound Cape Cod, Martha's Vineyard, and Nantucket street atlas. This will be the best $20 you spend on your trip, allowing you to navigate the back roads like a local, breezing from place to place while MA 28 and US 6 crawl along at a snail's pace. Another bane of the photographer's existence is parking. Beach parking lots can charge between $10 and $30 for a single day. Luckily, most places don't charge during the best light—before 9 AM and after 4 PM. Learning the roads and planning ahead are the best ways to avoid the summertime crunch.

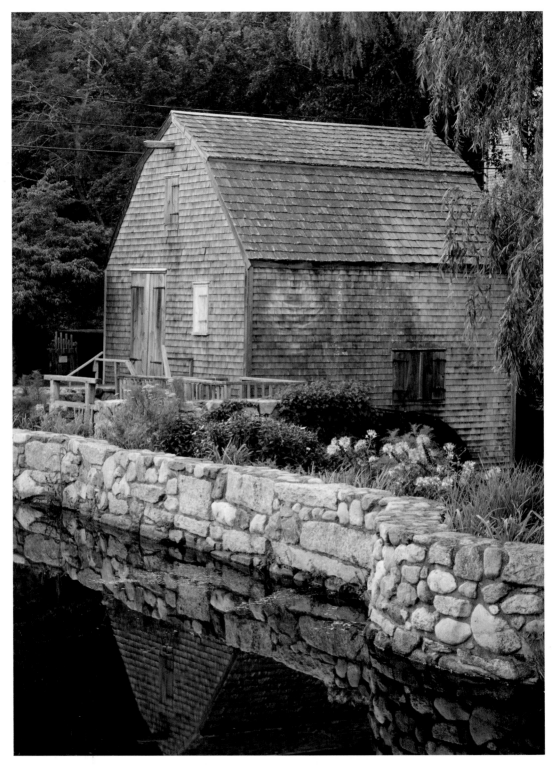

Dexter's Grist Mill, Sandwich Village

I. Bourne and Sandwich Area

SEASONAL RATINGS: SPRING ★★★ SUMMER ★★★★ FALL ★★★ WINTER ★★

General Description: Bourne and Sandwich, sitting astride the Cape Cod Canal, are the first towns visitors encounter when driving over the bridges onto Cape Cod. Bourne boasts colorful Buzzards Bay sunsets and quiet bogs and woodlands. Sandwich has a quaint, historic village center, extensive marshes, and the daffodil- and antique-laden start of the historic Old King's Highway (MA 6A).

Directions: Unless you fly directly to Cape Cod, you will pass through either Bourne or Sandwich on your way to the Cape from southeastern Massachusetts. Bourne lies to the west, along Buzzards Bay, and Sandwich is to the east, where the canal meets Cape Cod Bay.

Specifically: A number of sheltered coves on Bourne's Buzzards Bay coastline provide prime sunset-watching opportunities. If you are looking for traditional cedar-shingled Cape Cod quaintness, Sandwich village will delight you. Historic MA 6A, which starts under the Sagamore Bridge and heads "out-Cape" to the east, takes you along Cape Cod Bay past marshes, churches, and antique shops.

Cape Cod Canal Bridge View (1)

The Cape Cod Canal was created in 1914, although the original idea for linking the two tidal rivers was credited to Miles Standish of Plimoth Colony in 1623. Most people get their first view of the canal from one of the two bridges that span it—Bourne Bridge is the southwestern span and provides the quickest route to Falmouth and the Islands via MA 28, and the Sagamore Bridge is the northeastern

> **Where:** The northwestern region that separates Cape Cod from the rest of Massachusetts
> **Noted For:** Views of Buzzards Bay, Cape Cod Bay, the Cape Cod Canal, and historic buildings
> **Best Time:** Mid-May to June and September
> **Exertion:** Minimal
> **Peak Times:** Spring: mid-May; Summer: June; Fall: mid-October; Winter: January
> **Facilities:** At developed sites
> **Parking:** In lots
> **Sleeps and Eats:** Many in Sandwich
> **Sites Included:** Cape Cod Canal Bridge View, Four Ponds Conservation Area, Bennet's Neck, Red Brook Pond, Heritage Museums and Gardens, Sandwich Village, Mill Creek, Green Briar Nature Center, Maple Swamp Conservation Area

span, providing access to the Mid-, Lower, and Outer Cape regions via US 6.

I have mixed opinions about the canal itself. The manmade shoreline is far from beautiful—chunky bits of rocky riprap keep the swiftly flowing waters from eroding the shoreline. At the east end, a power plant stack disrupts the skyline. Heavy traffic roars up and down US 6 (along the north side) and MA 6A (on the south side). So, although it is a far cry from idyllic, there are well-maintained bike trails along either side, making access and viewing convenient. For bridge buffs, there is one shot you shouldn't miss. On the south side of the canal, there is a spot where you can look southwest and see the Cape Cod Canal Railroad Bridge (one of the largest vertical lift bridges in

the world) framed directly underneath the Bourne Bridge. Sunset is the time for this shot, since an orange and purple sky makes a dramatic backdrop for the silhouetted spans. Walk eastward from the Bourne Recreation Area lot directly underneath the Bourne Bridge for roughly 10 minutes, or until the spans line up.

Directions: There are numerous pull-offs where you can get out of your car and access either of the canal bike paths. To find the Bourne Recreation Area, head northeastward along MA 6A (south side of the canal) from the Bourne Rotary. Take a hairpin left onto Sandwich Road. Parking is on the right almost directly under the Bourne Bridge at the recreation area lot. The main lot is open from 9 AM to 7 PM, although if you arrive earlier or later there are a few parking spaces in the dirt to the left of the gate.

Four Ponds Conservation Area (2)

This wooded 133-acre conservation land links the four ponds of (from west to east) Shop Pond, The Basin, Freeman Pond, and Upper Pond. The ponds were created in the early 19th century by damming the flow of the Pocasset River. Miles of trails lead around and past the ponds, linking up with an even larger parcel of Bourne Town Forest land. The area is a shady, leafy escape from the bustle of Cape traffic.

The photographic highlights are the tranquil ponds and the flora and fauna they attract. For example, water-loving plants such as skunk cabbage grow here in early spring; as they unfurl they look like green elephant ears. Painted turtles sun themselves on logs and raccoons forage along the banks. It is well worth taking the time to prowl along the shoreline trails with your head down. Some of the flowers, such as

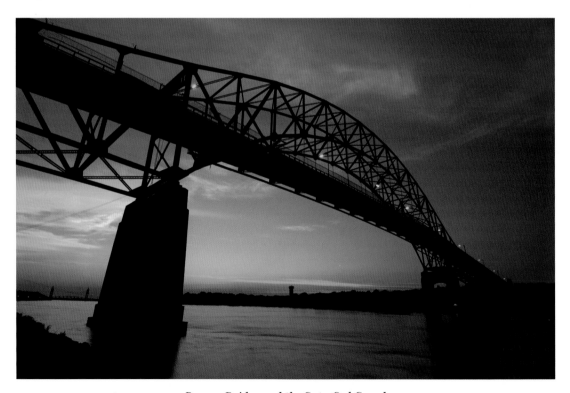

Bourne Bridge and the Cape Cod Canal

the endangered pink lady's slipper orchid, are easy to miss. In midsummer, four-foot-tall bracken and cinnamon ferns border the trails, providing leading foregrounds for compositions of the forests, ponds, and tiny rills connecting them. Use a wide-angle lens and point it downward into a bunch of ferns for a different perspective.

Directions: In Bourne, take County Road to Barlow's Landing Road, then drive east for 0.2 mile. Alternatively, you can reach the parking area from southbound MA 28 by taking a right-hand turn onto Barlow's Landing Road (the sign for "Pocasset/Wing's Neck") and driving 0.7 mile westward. The well-marked parking area has space for roughly 10 cars on the north side of the road.

Bennet's Neck (3)

Bennet's Neck is one of my Buzzards Bay sunset hotspots. From the dirt parking area, walk out onto either of two small headlands and explore the mile or so of shoreline. Looking west, you can see the low profile of Toby's Island. If chance favors you with a colorful sunset and calm, reflecting waters, use the island's silhouette as a compositional element. Beach rose grows here in summer, providing a colorful foreground or macro subject. Clammers occasionally work the flats at low tide, digging for a fresh shellfish dinner.

If the bay isn't providing any inspiration, there are some nice walking trails on the east side of the railroad tracks leading through the mixed pine and oak woods. The area to the north of the parking lot is called "Little Bay" and the area to the south "Monk's Park." A map of the hiking trails is posted just before the train track overpass.

Directions: From Shore Road in Bourne, turn west onto Valley Bars Road (dirt). Pass underneath the railroad bridge and follow the rutted

Bennet's Neck

dirt track to the left. The road ends at a parking lot for 10 to 15 cars.

Red Brook Pond (4)

This is a diverse conservation area linking dense woodland with several ponds and cranberry bogs. At the parking area, you can walk downhill to the edge of the pond to photograph the trees growing along the shoreline.

Spring (mid-May) and fall (mid- to late October) will bring either bright neon green or reddish-yellow-brown foliage, respectively. I have found that the light is best here in the late afternoon—a few hours before sunset, the sun paints the trees and pond with a warm glow. Once you have finished with the pond, walk down the trail behind the Bourne Conservation Trust map. The trail will parallel the dirt road and converge with it towards the end. Walk straight up the left side of the private driveway and you'll wind up back on the trail. The trail will branch—it's a loop so you could take either the North Trail or South Trail. Both will lead you through the forest to a network of cranberry bogs.

Look closely in the ditches to find frogs and turtles hiding in the duckweed. The cranberry plants and berries themselves can be very photogenic, especially in early spring and fall. Red foxes, white-tailed deer, and other mammals occasionally appear in the evening if you wait quietly.

Directions: From MA 28A in North Falmouth, drive north and take a left onto County Road (northwestward). Arriving at a fork, bear left onto Shore Road. You will drive by the western edge of Red Brook Pond. Take your next right onto Thaxter Road; the parking area will be just to the right.

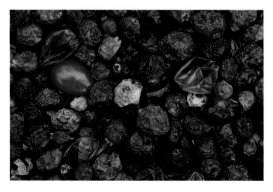

Cranberries, Red Brook Pond

Heritage Museums and Gardens (5)

This immaculately manicured 100-acre property is reminiscent of a sprawling English country garden. This is easily the finest flower photography location on the Cape and Islands. Unfortunately, all of that gardening comes with a hefty entrance fee—$12 for adults (good for two consecutive days if validated). If you enjoy photographing flowers, then pay the fee and pack a lunch, because you could certainly spend an entire day here. The staff will give you a map and direct you to the most photogenic areas.

Bright yellow daffodils take the center stage in early spring (April). Later in the spring (mid-May through mid-June), a world-renowned rhododendron collection is in bloom, turning the trails into a blur of pink and purple blossoms. Later in the season, from July to early August, the color shifts to orange and yellow as thousands of day lilies open up. Blue and purple hydrangeas, a Cape Cod favorite, also appear in late summer.

Your hardest problem at Heritage Gardens may be picking out which flowers to photograph. Pay attention not only to the quality of the subject but also the quality of the background. Look for a background that is free of distracting branches and bright highlights. Frequently, shifting position by a few inches will result in a significantly different background.

The best possible conditions for macro photography are windless days with high overcast clouds. In addition to the flowers, there are several museums (including a working carousel) and a windmill on the property.

Directions: From Exit 2 off US 6, turn north onto MA 130. At the triangle intersection, bear left, then take your next hard left past Town Hall onto Grove Street. The entrance to Heritage is on the left about 0.5 mile down the

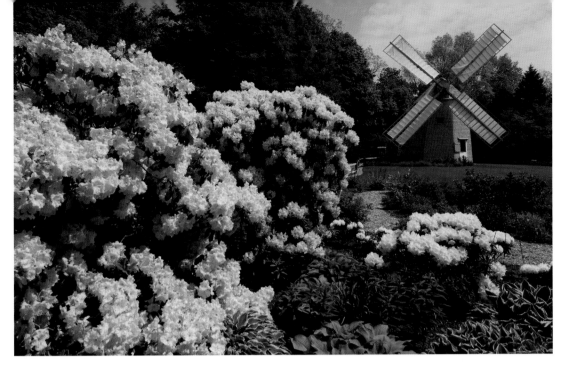

Heritage Museums and Gardens

road. Heritage Museums and Gardens open on April 1 and close on October 31; they are open daily from 10 AM to 5 PM.

Sandwich Village (6)

The Cape's oldest town, and arguably one of the most picturesque, Sandwich was founded in 1637. If you're looking for pictures of idyllic country scenes from the Cape's bygone days, this is the place. Start at the beginning—Cape Cod's oldest saltbox-style house, Hoxie House, sits on the edge of tranquil Shawme Pond. A modest fee ($3) is charged to tour the inside. This ticket can be combined ($4) with a visit to Dexter's Grist Mill, which is a short walk northward along MA 130. Seasonal flowers and stone walls provide a backdrop for this historic mill building. Just around the corner is another photogenic building, the Town Hall, identified by the tall Greek columns in front. These historic structures get a nice front-light in morning. Also, consider stopping by at twilight, when some of the buildings, including the tall white steeple of the First Church of Christ, are floodlit.

Directions: From Exit 2 off US 6, turn north onto MA 130 (also named Water Street). This road will take you right into the center of town. Parking is along the street on Water Street and Main Street.

(7) Mill Creek

This is a great place for walking and exploring marsh and beach ecosystems, especially at sunrise when there are fewer visitors. It is not the best spot for sunsets since the sun will sink behind the eastern terminus of the Cape Cod Canal—the power plant smokestack is hard to avoid. However, there are several pleasing landscape views along the long, tall boardwalk that takes you over Mill Creek. The trail continues past marsh grasses and sand dunes, ending at a beach overlooking Cape Cod Bay.

Shooting out over the marsh grasses, especially in fall when they turn a deep russet, is particularly rewarding. Search the banks of Mill Creek for portraits of gulls and shorebirds. The boardwalk, especially the tall section nearest the main parking lot, is photogenic at the edges of the day when the span is silhouetted.

Directions: From Sandwich center, take Jarves Street north, then turn left on Factory Street. Take a right on Harbor and a left onto Boardwalk. Follow Boardwalk Road until it ends at the parking lot.

Green Briar Nature Center (8)

Despite this 57-acre site's small size, it is packed with photo subjects. Owned by the Thornton Burgess Society, the nature center and adjoining trails are dedicated to the author of the Peter Rabbit children's tales. From the 40-car parking area, walk up the road around the Nature Center to a small boardwalk overlooking Smiling Pool. In summer, a family of European mute swans routinely patrols the pond. The cranberry bog on the other side of the road is the place to look for blue flag iris and bullfrogs. Flower lovers will delight in the small garden, full of native species. If you get tired of shooting, visit the authentic jam kitchen or the small natural history library.

Directions: From US 6, take Exit 3 and head northwards to MA 6A. Take a left and head westward for about 0.5 mile—the Green Briar Nature Center will be on your left.

Maple Swamp Conservation Area (9)

"Swamp" usually doesn't conjure up a lot of positive images about dream photography destinations. However, don't let this conservation area's name fool you—swamps there are, but there are also some steep hills with views of Cape Cod Bay, making it a unique area (if you have spent any amount of time on the Cape,

one of the things you are bound to notice is how flat it is—the highest point is just over 300 feet in elevation). So, strap on your hiking boots and get ready for some "mountaineering." Take the right-hand trail from the parking lot. You will immediately start gaining elevation. You will encounter a few switchbacks as the trail climbs steeply through the oak and pine forest. Take a right at the first major trail junction (it will also climb steeply) and you will arrive at a picnic table and a small opening in the trees looking northward to Cape Cod Bay (elevation roughly 150 feet). The opening in the trees is somewhat narrow (more open in winter than summer), so your shooting possibilities are limited.

There are lots of opportunities to find other woodland subjects along the way, including swamps, vernal pools, and tiny wildflowers in the spring. The trails here are extensive, so take your time (and your bug spray, if you visit in summer) and enjoy the woods away from the crowds. This is also a great spot to come after a snowfall since all of the trees will be transformed from boring naked branches and limbs to white-draped loveliness.

Directions: From US 6, take Exit 3 and drive south about a hundred yards. Take a left onto the Service Road and follow it east for one mile. A large sign on the right will guide you to the ample parking area.

Recommendations: Many visitors, in their rush to get to Martha's Vineyard or the broad sandy beaches of the Cape Cod National Seashore, blow right by Bourne and Sandwich. As a result, many of these locations are considerably less visited than the more popular Outer Cape and Island sites. The coves along Buzzards Bay are among my favorite sunset locations. A drive along Shore Road in Bourne allows you to appreciate just how stunning it is here at sunset.

On a misty or cloudy day, explore Red Brook Pond or the Four Ponds sites for flora and fauna photos—you will have these locations all to yourself. Sandwich is a great town to explore for both photographers and nonphotographers alike. Park your car and walk around the town, Heritage Gardens, the marshes and beach, or Maple Swamp area, depending on the weather conditions.

Pro Tips: Sunsets can be notoriously difficult to render on film (or digital media) because the sun has a tendency to fool the camera's light meter. If you let your camera do the thinking, the meter will be overwhelmed by the bright reading from the sun and compensate by stopping down the aperture or speeding up the shutter speed. The resulting images will always come back dark and unusable. When photographing a sunset scene, first meter the light without the sun in the composition. Then, lock the exposure and recompose with the sun in the scene. Voilà, perfect exposure.

When photographing people (or any other subject) in the foreground with a sunset in the background, use some fill flash or you'll wind up with an unrecognizable silhouette. If you have the capability, position your flash off-camera to minimize red-eye. Another inexpensive but useful tool is an amber (orange) colored gel that can be taped over your strobe head. The gel will make the strobe light warmer, matching the warm color temperature of the ambient light.

Cautions: If you're driving in from out of town, the Bourne Rotary will be your first introduction to the Cape Cod traffic circle. Although negotiating a rotary may seem patently obvious, you would be surprised at the "creative" driving I have seen at this one in particular. There are a few simple rules to observe to make your and your fellow drivers' lives much happier. When approaching the rotary, slow

Smiling Pond, Green Briar Nature Center

down. Entering traffic always yields to rotary traffic, so don't floor it and play chicken with the cars already in the rotary. When there is an opening, drive in, only in the counterclockwise direction (to your right). When you reach your exit, make your way to the outside of the circle, signal, and drive out. Lastly, don't stop in the middle to read a map.

Diversions: Sandwich's many museums will keep you busy when the weather makes you keep your camera in the case. The Sandwich Glass Museum, on Main Street, will give you an insight into Sandwich's 19th-century glass-making heritage (complete with glassblowing demonstrations). The Hoxie House and Thornton W. Burgess museums are on the west side of Water Street, south of the "triangle." Heritage Gardens also houses the Cape Cod Baseball League Hall of Fame, an auto museum, history museum, and an art museum (complete with working carousel).

II. Falmouth and Mashpee Area

SEASONAL RATINGS: SPRING ★★★★ SUMMER ★★★ FALL ★★★★ WINTER ★★★

General Description: The town of Falmouth sits in an enviable location, separating the waters of Buzzards Bay (west) from Vineyard Sound (south). It is the main departure point for ferries to the island of Martha's Vineyard, and home to many attractive beaches, forest hikes, and historic homes. In short, there is something for everyone in this area. If you tire of photography or the weather deals you a bad hand, there is the Woods Hole Oceanographic Institution Exhibit Center and the Science Aquarium, both located in the picturesque village of Woods Hole.

Directions: From the Bourne Bridge, drive south on MA 28. For a more sedate and photogenic drive, try MA 28A instead, which parallels MA 28 to the west.

Specifically: This section may appear a bit biased since Falmouth is my backyard. The Buzzards Bay beaches, littered with glacial erratic boulders, make ideal sunset spots. The tiny village of Woods Hole, located on a narrow isthmus of land, is a great place to get pictures of science labs, seals, and sailboats. Nobska Light, perched on a headland across from Martha's Vineyard, is one of the Cape's most photographed lighthouses.

Wild Harbor (10)

This small harbor in North Falmouth is tucked away at the end of a maze of quiet residential streets. In summer, colorful sailboats and dinghies are moored in the harbor. Fishermen cast their lines from the ends of the rock jetties. Since the sun sets over the waters of Buzzards Bay, evening is the time to visit. A moderate wide-angle lens will take in the whole scene. If the sky isn't interesting, don't include it in your

> **Where:** The southwestern corner of Cape Cod
> **Noted For:** Lighthouse, beaches, forest hikes, harbors, and historic churches
> **Best Time:** June to early July and mid-September to mid-October
> **Exertion:** Minimal
> **Peak Times:** Spring: Mid-May; Summer: June; Fall: mid-October; Winter: January
> **Facilities:** At developed sites
> **Parking:** In lots and roadside
> **Sleeps and Eats:** Many in Falmouth and Woods Hole
> **Sites Included:** Wild Harbor, Old Silver Beach, Bourne Farm, Little Island, West Falmouth Harbor, Quissett Harbor and The Knob, Beebe Woods, Peterson Farm, Woods Hole Village, Nobska Point Lighthouse, Shining Sea Bikeway, Spohr Gardens, Ashumet Holly and Wildlife Sanctuary, John's Pond, South Cape Beach State Park

photos. Instead put on a telephoto lens (or just zoom in) to isolate the sailboats or the reflections of their hulls in the sparkling water.

Directions: From the intersection of MA 151 and MA 28A, drive south on MA 28A. At the oval-shaped rotary, take the first exit to the right for Old Silver Beach. This will put you on Curley Boulevard (also called Shore Road). After roughly a mile, turn right onto Quaker Road. Next, turn left onto Crystal Spring Road. Follow it until it ends, then turn right onto West Avenue and you will come to the small harbor. Parking is along the roadside.

Old Silver Beach (11)

This beach, located in a can't-miss spot on Quaker Road in North Falmouth, is popular with a younger crowd in summer because it is

one of the few sandy Buzzards Bay beaches. The water here is also quite warm in the summer. Sand can often provide interesting foregrounds, including human and avian footprints and sand formations like ripples and waves.

Unless you really like crowds, I recommend hitting Old Silver on the shoulder seasons or midweek just before sunset. There are a number of other Buzzards Bay spots where you can enjoy more midday solitude. Another attraction besides the obvious sunset-over-beach shots is the winding Herring River and unobstructed salt marsh on the other side of the road. You can capture landscape shots of the marsh, dotted with egrets and herons standing statue-like in the grasses, right from the bridge. A short dirt road will take you a couple of hundred yards closer, where you may be able to get a better shot at the marsh wildlife, especially at low tide. The area looks best in a thick summer fog, when the egrets stand ghostlike amid the green and brown marsh grasses.

Directions: Old Silver Beach is easily found off of Quaker Road in North Falmouth between West Falmouth Harbor and Wild Harbor, next to the Seacrest Resort. Parking for nonresidents is $20 in summer, and there is often a line of cars waiting for the gates to open in the morning. After 5 PM, parking is free.

Herring River, Old Silver Beach

Bourne Farm (12)

Fields and farmland surround this historic 1775 farmhouse. The farmhouse and barn, complete with grape arbor, are located on a grassy knoll overlooking Crocker's Pond. The front side of the farmhouse (facing the highway) is front-lit in the morning and the back is lit in the afternoon. The property surrounding the farm is preserved for public walking (though occasionally rented for wedding receptions). A small pond (Crocker's Pond) lies in a depression to the south; it's a good place

to photograph reflections of foliage on still days. At the western side of the property, clearly signposted trails lead through the forest to quiet cranberry bogs and streams. Place the old stone fences in your photograph to lead the viewer's eye through your frame. On Columbus Day weekend the conservation committee holds a pumpkin sale. The piles of pumpkins make colorful pattern photos.

Directions: From MA 28, take the Thomas B. Landers Road exit and drive west. The farm is at the intersection of MA 28A and Thomas B. Landers Road.

Little Island (13)

This peninsula (it's not really an island) is one of the Upper Cape's local secrets—I'll probably get in trouble for leaking it. It is one of my favorite spots to beachcomb and watch the sun set over Buzzards Bay. There are no signs to mark the way to this small conservation area, so it's hardly ever crowded. From the tiny (three to four cars) parking area, walk down the sandy path, then proceed counterclockwise around the rocky shore. A full circuit, which can be completed only at low tide, will take

Little Island

around 30 to 40 minutes. At high tide a small stream will cut off the island's southern trail.

The main point of photographic interest is the collection of boulders along the shore (also known as "glacial erratics" since they were deposited here during the last ice age). At all stages of the tide, they provide a perfect foreground for sunset photos. Open up your shutter speed to blur the water swirling around the rocks. Interesting shells can be found here; in winter, storms can dump heaps of mussel and scallop shells onto the beach. Sea birds such as cormorants, divers, and ducks frequent this area; bring the long telephoto lens.

Directions: From the West Falmouth Market on MA 28A, drive west on Old Dock Road. After the train tracks, turn right onto Nashawena Street. After crossing a small bridge, turn left onto Little Island Road and follow it to the end.

West Falmouth Harbor (14)

Beginning in June, the small boat landing at the eastern end of West Falmouth Harbor becomes crowded with 20 to 30 dinghies. The dinghies are used by boat owners to get to and from their sailboats moored in the harbor. The dinghies themselves, tied up together like a little kid's armada, make excellent photo subjects both from afar and up close. Sunset is my preferred time to be here, when on a calm day the still water of the harbor creates perfect reflections. Be prepared for the sand flies, though—they are thick at sunrise and sunset on calm summer days.

After shooting the landing, check out the rest of the harbor from the road or from Chapoquoit Beach. As you drive along Chapoquoit Road, look to your right and pay attention for changes in the lighting on the boats and water.

You may find that the best vantage point of the harbor is along the road. The road is narrow but cars drive slowly, so it's no problem to backtrack on foot from the beach parking lot to get a better angle. In addition to the boats, there is a small network of sand dunes on the harbor side of Chapoquoit Beach. All sorts of sea critters can be found here at low tide.

Directions: Drive west on Old Dock Road across from the West Falmouth Market on MA 28A. Keep going straight after the train tracks—the parking lot for the boat landing will be immediately on your right a hundred yards past the tracks. If that lot is full, backtrack to the big dirt lot at the train tracks. For alternate views of the harbor, continue on Old Dock Road until it dead-ends, then turn right onto Chapoquoit Road. Follow it to the large beach parking area (resident sticker only in summer). If you don't have a resident sticker you can always walk from the dirt lot (10 to 15 minutes).

Quissett Harbor and The Knob (15)

This is another Upper Cape gem, although it's not as hidden as it once was. A sizable collection of sailboats and dinghies fills this small harbor throughout the summer, and shooting is easy from the many vantage points on the narrow road to the parking lot.

Most people come here to enjoy a small sandy crescent of beach accessible via a narrow conservation land trail through the forest. The trail begins at the Quissett Yacht Club pier (on the left just before the entrance to the private road), and leads for about a half mile to an outcrop of rock about the size of a two-story house called "The Knob." This is a very popular spot to watch the sun set over Buzzards Bay—even midweek you may see a small crowd gathered on the outcrop. Although the panoramic view from the outcrop is nice, I prefer to include The Knob itself in my composition, so I set up my tripod along the trail. On some winters when the temperatures stay subfreezing for a week or more, sea ice can form in the bay. The landscape is transformed into the Arctic for a few days or weeks, depending on the temperatures.

Directions: Traveling south on Woods Hole Road, pass Falmouth and continue to the traffic lights. Turn west (right) onto Quissett Harbor Road, pass one stop sign, and continue down the hill into the harbor. There are two small parking areas on the right side of the road. On summer weekends the parking areas will fill up quickly, so plan to arrive before 9 AM or after 7 PM. Park only in designated spots—cars illegally parked run the risk of being towed.

Beebe Woods (16)

Tired of the beach scene? The miles of broad, well-marked trails crisscrossing this forest provide a respite from the beach crowds. During colonial times this entire area was sheep and cattle pasture—so this forest, like many woodlands on the Cape, is quite young. Wildflowers like trailing arbutus (mayflower), pink lady's slipper, swamp azalea, and rhododendrons flourish here throughout the spring and summer. In early spring (mid-May), misty days cre-

West Falmouth Harbor

ate a soft light for newly sprouted bright green leaves. You will find several picturesque groves on the way to Deep Pond (also known as the "Punch Bowl"), a kettle pond located about a mile from the parking area.

In late October, red and yellow leaves carpet the ground and old stone walls. Use a wide-angle lens and point your camera downward, letting the wall curve away into the background. My favorite weather for photographing in Beebe Woods is a thick fog, which occurs frequently in summer when warm winds blow over the cool waters of Vineyard Sound. Fog reduces the oftentimes too-cluttered look of the forest, reducing the forest landscape to a series of simple outlines and shapes. This is a popular dog-walking area, so don't expect to see much wildlife.

Directions: Follow MA 28 southward into Falmouth. Just after the "Queen's Buyway" shopping area (which is on the left), take a right onto Depot Avenue. Pass the bus depot and cross the bike path, continuing up the hill past Highfield Hall and the Highfield Theatre, home of the College Light Opera Company, to the large parking area in front of the Cape Cod Conservatory. Maps of Beebe Woods and Peterson Farm are available from the Falmouth 300 Committee. Their offices are located at the junction of the Shining Sea Bikeway and Woods Hole Road.

Peterson Farm (17)

Visit the fields of this old farmstead to find wildflowers and field-loving birds such as barn and tree swallows. Large swaths of black-eyed Susans and milkweed attract a plethora of insect life including crab spiders and bumblebees. A herd of sheep and their guardian llama patrol the borders of their fenced domain. On the weekends you can sometimes watch border

Buzzards Bay sea ice at The Knob

Icehouse Pond, Peterson Farm

collies practicing their herding skills. Near the parking area you may be able to find some old farm machinery that is rusting away. Trails here can connect you to the Beebe Woods area for a longer hike (maps of Beebe Woods and Peterson Farm are available from the Falmouth 300 Committee—see Beebe Woods, above).

After taking in the flowers (if they are in season) at the farm area, walk counterclockwise around the fence until you get to the northwestern corner. From here a path will lead westward into the forest. After 10 minutes you will arrive at the edge of Icehouse Pond, a peaceful spot where you can sometime spot turtles resting on logs and foliage reflected in the water.

Directions: Traveling south on Woods Hole Road, turn right on McCallum Drive and then take an immediate right up a steep hill to a small parking lot at the base of the water tower.

Woods Hole Village (18)

Many people see this postcard-perfect village only as they are departing or returning on the ferry to Martha's Vineyard, but they are missing one of the best gems on the Cape. There is much to see and photograph here, despite the pocket size. Aside from a few restaurants and watering holes, most of the buildings here belong to a collection of world-class oceanographic research institutions. The private and government research organizations include Woods Hole Oceanographic Institution, Marine Biological Laboratory, National Marine Fisheries, and National Oceanic and Atmospheric Administration. Their historic buildings are best photographed at twilight from across Eel Pond (the small body of water on your right as you enter Woods Hole). Take a short walk down School Street past the Children's School of Science and set up your tripod with a great view of the pond in the foreground and the research buildings in the background.

The drawbridge in the heart of the "downtown" is a great spot to hang out and watch the sailboats coming and going. The drawbridge is frequently raised in summer, which is a great photo opportunity. You may run into a famous photographer named Chris Linder at his

Nobska Point Lighthouse

favorite coffee shop, Coffee Obsession II, right in downtown Woods Hole. If you buy him a chai tea he'll sign this book for you. . . .

Directions: Follow Woods Hole Road south from Falmouth right into Woods Hole. Parking is by parking meter along the streets. The parking police are vigilant in summer—if your meter runs out, count on a ticket.

Nobska Point Lighthouse (19)

This is one of the most photographed lighthouses on Cape Cod. The tower and keeper's house date from 1876. The commander of the Woods Hole Coast Guard group lives here, so don't jump the fence to get a better angle—you wouldn't want someone traipsing all over your lawn putting tripod holes in the grass. Since the lighthouse is on a small headland, it's difficult to get a photo that isn't tilted upwards. Although the effect can be used artistically (like the cover shot of this book), I generally prefer to avoid those "looking-up" shots since they tend to make vertical lines converge, giving the lighthouse a slightly drunken appearance.

For a different angle on this popular icon, continue eastward on Surf Drive along Vine-yard Sound towards Falmouth until it converges with the Shining Sea Bikeway. Sunset is the perfect time to photograph Nobska Light looking down the coast—it will appear as a small silhouette, but if you wait until the right moment when the lighthouse's beacon is facing you, you'll have the exclamation point in your photo.

Directions: From Woods Hole village, take a right onto Church Street. Follow this road for about a mile and you'll see the lighthouse on your left. There are a handful of spots to park here in the small lot.

Shining Sea Bikeway (20)

This paved bike route runs along a former rail line from Falmouth (although plans are underway to extend it up to North Falmouth) into Woods Hole village. The bike path itself can get crowded with bikers, joggers, and roller-bladers in the summer, but there are a couple of notable photography areas off the main (paved) path. I highly recommend visiting the Cape Cod Salt Pond Sanctuary trails on the south side of the bike path near the Elm Road parking area (room for three cars). The marshy soil encourages the growth of large ferns. In late April and early May, bring the macro lens to capture the tiny newborn fern fiddleheads. Wildflowers can be found here throughout the summer and early fall. In early September, look for the large fragrant pink blossoms of musk mallow near the water.

Osprey can also be photographed here as they dive-bomb for fish in the ponds and carry large branches to their nesting platforms. Most of the platforms are located on poles erected in the middle of the salt marsh ponds along Surf Drive. Keep your distance to avoid disturbing the birds.

Where the bike path crosses Surf Drive, you begin to see Vineyard Sound. Just off the path,

you can find the pink blossoms of beach rose and beach pea. A little further on, red-winged blackbirds can be found calling from their perches on swaying cattails in the marsh.

Directions: The three main bike path parking areas are (1) where Woods Hole Road meets Mill Road, (2) where Elm Road crosses the bike path, and (3) where the bike path meets Surf Drive.

Spohr Gardens (21)

Tucked away down a quiet side lane is this stunning 6-acre property fronting Oyster Pond. The gardens were the labor of love of Margaret and Charles Spohr, who donated the property to a charitable trust in 2001. In spring the paths are awash with yellow and white daffodils, and later in the summer rhododendrons and day lilies bloom. There is no charge (though donations are encouraged) to tour the gardens. A collection of historic anchors and mill stones are interspersed between the rows of flowers, ferns, and decorative shrubs and trees.

Directions: From the traffic light on Woods Hole Road, go southeast (left as you're heading towards Woods Hole) on Oyster Pond Road, then left on Fells Road. Parking for roughly 10 cars is just across from the gardens.

Ashumet Holly and Wildlife Sanctuary (22)

Solitude is the norm at this relaxing site maintained by Mass Audubon. The main draws at this 45-acre nature preserve are the diverse species of tall, stately holly trees scattered along the well-maintained trails. The trails wind around a shallow pond and through a tall white pine forest—try pointing a wide-angle lens straight up at the boughs overhead, or use a telephoto to make interesting pattern compositions of the trunks. Great blue herons, Canada geese, and numerous other marsh birds feed and roost near the pond. An active family of

swallows returns to nest every year at the old barn near the entrance and can be seen zipping around catching insects in the evening.

Directions: From MA 151, roughly midway between MA 28 to the west and the Mashpee Rotary to the east, take Currier Road north for a hundred yards until it intersects Hooppole Road. Take a right and the parking lot is immediately on your left. Admission is $3 (free for Mass Audubon members).

John's Pond (23)

The highlight of John's Pond is, ironically, not the pond itself but the miles of trails looping through the woodlands and bogs to the northeast of the pond. It's easy to get lost here if you want to wander, but I prefer to stick to the open areas about a quarter mile from the parking lot. The ideal weather and season for this area is a light mist in autumn or puffy-cloud blue-sky day in late summer. A large stand of tupelo trees grows here; their small round leaves turn a brilliant red in mid-October. Visit on a day with light mist or rain for the most intense color saturation.

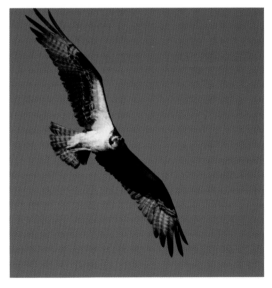

Osprey, Shining Sea Bikeway

Use a polarizing filter to make the colors pop even more—rotating the polarizer will eliminate distracting reflections from the wet leaves. On those misty days, exclude the sky from your shots, since it will be a distracting, washed-out white. When the sky really sings—brilliant blue with cotton-candy clouds—put on your wide-angle lens and take in the wildflowers and open bogs with the forest in the background.

Directions: From MA 151, drive north on Currier Road. Take a right onto Ashumet Road, then a right onto Hooppole Road, stay right when the road forks. After about a mile, turn right onto Back Road and follow to the beach parking lot. A town parking sticker is required in summer from 9 AM to 4 PM, but the area is open from 5 AM to 9 PM, so if you don't have a sticker come early in the morning or late in the afternoon.

South Cape Beach State Park (24)

This popular park sits on a peninsula overlooking Vineyard Sound and the island of Martha's Vineyard. Trails take you to ponds and inlets or along the 2 miles of sandy beach.

Even if crowds are mobbing the beach near the parking lot, it doesn't take much walking to have the beach all to yourself. Start by heading west past the end of the boardwalk to the western section, called "Dead Neck." If the weather is favorable for landscape photography, focus on waves and water to the south or tranquil Sedge Lot Pond to the north. A diverse collection of sea birds often congregate in the pond.

Directions: From the MA 28 rotary in Mashpee (near the large Mashpee Commons shopping center), follow Great Neck Road south. Bear left onto Great Oak Road. Follow signs to South Cape Beach State Park. Note that the parking area is split into two areas: turn left for the public lot ($7 in summer from 9 AM to 4:30 PM) or right for the town sticker lot.

Recommendations: Falmouth is a rich area with much to see and do. It is easy to plan out a full day's (or week's) worth of very rewarding shooting. If the forecast calls for clear weather, I would start on Vineyard Sound for sunrise, working compositions along the Shining Sea Bikeway. Once the golden light has faded, head to Woods Hole village for lunch and to shoot sailboat and dinghy reflections in Eel Pond. Finish the day working one of the Buzzards Bay spots like The Knob, Little Island, or West Falmouth Harbor. If you get fog or mist instead, try an inland location like Spohr Gardens, Peterson Farm, or Beebe Woods for macro shots, or do some shopping on Falmouth's Main Street.

Pro Tips: A full range of lenses is useful for this area. Use a wide angle at an area with foreground interest. For example, at Little Island, try pointing the lens downward at some boulders. Instead of placing the horizon at the center, put it at the top third of the viewfinder. This will create a sense of depth in your image so that your viewers will feel like they can walk right into your photograph. If your foreground is dark, consider adding a split-graduated ("split-grad") neutral density filter to darken a bright sky (which balances the contrast range).

A telephoto can also be useful in Falmouth. Beginning in April there are several pairs of nesting osprey along Surf Drive (near the Shining Sea Bikeway). If you are patient you can photograph them diving for fish in the salt ponds or returning to their nests. Other photogenic birds include eider ducks and cormorants (both can be seen in Vineyard Sound and Buzzards Bay) and some acrobatic swallows at Peterson Farm and Ashumet Holly Sanctuary. Red-winged blackbirds are easily photographed at any salt marsh. Mammals including red foxes, skunks, and coyotes are particularly active in early summer when they are feeding

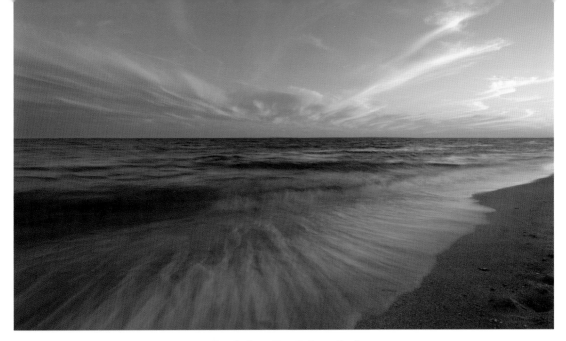

South Cape Beach State Park

their young. It is not uncommon to see several coyotes loping down a quiet country road side-by-side in the early morning or late evening hours.

Cautions: Late spring or summer beach shoots at the edges of the day in calm conditions will require a lot of bug spray or infinite patience, as the blood-sucking sand flies will be in swarm mode. If the wind picks up, pay attention to the wind direction when you're photographing those crashing waves. If the wind is blowing straight at you across the water, your lens is going to get coated with salt spray in a matter of seconds. When the wind is at your back you should have no problem shooting freely, but don't forget to wipe down your gear with a clean, damp cloth when you get back to your lodging. Unlike Cape Cod National Seashore beaches, most of the Buzzards Bay locations have more rocks than sand. At low tide the wet rocks can be very slippery, so watch your footing. Lastly, do not exceed your parking meter time in Woods Hole—the parking police are vigilant, especially from June through August.

Diversions: If you need a break from photography, visit the Woods Hole Science Aquarium, open from 11 AM to 4 PM from Tuesday to Saturday. The aquarium has a harbor seal show, great collections of local marine life, and a touch tank that children enjoy. Also in Woods Hole, the Woods Hole Oceanographic Institution Exhibit Center (open from 10 AM to 4:30 PM Monday through Saturday) features information about current worldwide oceanographic research. You can buy t-shirts, books, and other oceanography paraphernalia. The hours and times for both museums are reduced in the off-season (check their websites for times: http://aquarium.nefsc.noaa.gov/; www.whoi.edu/home/about/visitor_exhibit.html). If you want to take home some local flavor, stop by Bill and Ben's Chocolate Emporium on Falmouth's Main Street. Try the saltwater taffy or some homemade chocolate—I guarantee you won't walk out empty-handed.

III. Barnstable Area

SEASONAL RATINGS: SPRING ★★ SUMMER ★★★ FALL ★★ WINTER ★

General Description: Barnstable is the central hub of Cape Cod—you can access planes, boats, and buses here. The city of Hyannis, stretched out along MA 28 in the south of the county, can be maddeningly busy during the summer. However, it's easy to find solitude among the miles of rolling dunes at Sandy Neck on Barnstable's Cape Cod Bay shore.

Directions: Exits 5 and 6 off US 6.

Specifically: The Barnstable area is dominated by three major east-west roads of vastly different character. Choose the northern route (MA 6A) for Sandy Neck and historic homes and churches. Choose the middle route (US 6) to pass through as quickly as possible to the Lower and Outer Cape. Choose the southern route (MA 28) for the towns of Osterville, Centerville, and the metropolis of Hyannis, which is home to the JFK Memorial, Kalmus Beach Park, and many tourist attractions.

> **Where:** The beefy bicep of the Cape Cod arm, midway between the bridges and the elbow
> **Noted For:** The Kennedy Memorial, beaches on both Cape Cod Bay and Vineyard and Nantucket Sounds, and the broad dunes of Sandy Neck
> **Best Time:** Late May to June and September
> **Exertion:** Minimal for urban sites, moderate at Sandy Neck
> **Peak Times:** Spring: May; Summer: June; Fall: late October; Winter: January
> **Facilities:** In towns
> **Parking:** In lots
> **Sleeps and Eats:** Many in Hyannis and along MA 6A
> **Sites Included:** Sandy Neck and Great Marshes, Bridge Creek Conservation Area, Hathaway Ponds Conservation Area, Bryant's Bay, Crocker Neck, Mill Pond, Osterville Village, Skunknett Brook Sanctuary, JFK Memorial, Kalmus Beach Park

Sandy Neck and Great Marshes (25)

Sandy Neck is the largest stretch of preserved beach on Cape Cod Bay, extending eastward for 6 miles. The sand dunes and marshes form a protective barrier to the Great Marshes and Barnstable Harbor to the south. A loop trail runs from the parking lot along the beach and back through the marshes. Four connecting trails link the beach side to the marsh side, offering plenty of flexibility for hiking. I recommend starting out on the marsh trail, since the beach adjacent to the parking lot can be crowded with sunbathers and off-road vehicles (driving on the beach is legal here with a permit). From the parking lot, backtrack along the road until you reach the tollbooth, then hike eastward on the track through the marshes. The trails between the beach and marsh are the best places to photograph the dunes since they afford you a high vantage point. Looking north, the turquoise blue of Cape Cod Bay spreads before you, and looking south, the browns and greens of the Great Marshes.

Dune flora, such as dusty miller, compass grass, and seaside goldenrod make photogenic subjects. You will also come across some small homes nestled amid the dunes—they are private, so be respectful of the landowners' prop-

erty. I prefer to visit on clear mornings and afternoons for sand dune photography, since the low sun angle will make interesting shadows behind the sand ripples. On an overcast day, the dunes tend to lose their shape and definition. Keep in mind that hiking on sand is grueling—always bring plenty of water and don't hike beyond your ability.

At the end of the spit, a small collection of homes rings the small, privately owned Sandy Neck Lighthouse. I have gotten my best shots of this enclave from the Hyannis Whale Watcher cruise boat, which departs from Barnstable Harbor and passes the lighthouse just offshore. Alternatively, you could paddle over in a kayak for closer views.

Directions: From US 6, take Exit 5 and drive north on MA 149, then turn left onto MA 6A. After 3 miles, turn north onto Sandy Neck Road and follow it to the parking lot.

Bridge Creek Conservation Area (26)

Bridge Creek is one of those serene wooded places where you can feel miles away from the rest of Cape Cod. Crumbling stone walls mark the borders of former pastures. They are especially photogenic in the autumn when colorful fallen leaves add decoration. Winter is also a special time, both because of the lack of biting flies and because of the storybook facade of the forest after a fresh snowfall. There are miles of trails to explore here, but I will focus on my favorite areas.

From the parking lot, shoulder your camera bag and walk down the path to the first fork. Taking the lefthand route leads to an inviting fern-carpeted (but mosquito-filled) wonderland. There are opportunities for both macro shots and landscapes—use the aforementioned stone walls and ferns as compositional elements. If you take the right fork (follow the

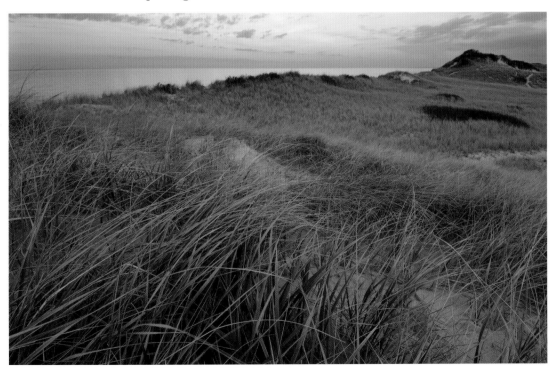

Sandy Neck dunes

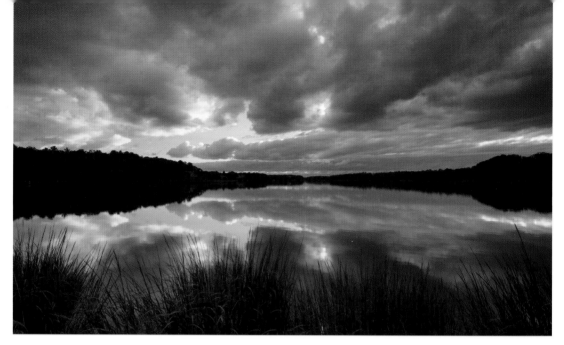

Bryant's Bay

blue triangle blazes on trees), the path will lead you to vistas of the marsh. Bring some waterproof boots or hip waders if you want the best vantage points, because the lush vegetation can sometimes obstruct the view from the path.

Directions: Take Exit 5 off US 6, head north on MA 149 for 0.2 mile, and turn right (eastward) onto Church Street. Drive for roughly 1.5 miles and look for the small (five cars) parking area on your left.

Hathaway Ponds Conservation Area (27)

Three busy roads surround this small conservation plot, so it is not as quiet as Barnstable's other natural sites. Despite the distant rumble of cars and trucks, the scenery makes you feel like you're miles from civilization. Two glacially formed kettle ponds (aptly named Little and Big Hathaway) are the main points of interest. A short 1-mile trail leads around Big Hathaway Pond, affording you the opportunity to make a number of different pond landscapes. In addition, a very short (five-minute) trail will take you to the edge of Little Hathaway Pond. Landscape shooting will be limited here because of the power lines in the background. There are a wide variety of macro subjects along the pond edges, including damselflies and wildflowers. The best way to find wildlife is to let it come to you. Pick a comfortable spot and wait quietly— something is bound to turn up.

Directions: From US 6, take Exit 6 and head southeastward on MA 132. At the light for Phinney's Lane, take a left and look for the Conservation Area sign on your left. If you arrive before the gate is open (9 AM), there are a few spots for parking at the side of the road in front of the gate.

Bryant's Bay (28)

This is one of those easily overlooked spots that can come alive with good light and dramatic weather. There are no facilities or trails here, just a great view. Looking southward from the bridge of the Santuit River, Bryant's Bay spreads out before you. Place the tall marsh

grasses in the lower portion of your photo to give the image some depth and context. On windless days, the calm waters will reflect the clouds overhead. The options for exploration are limited here since there is not much room between the bay and the road. Take extra care to set up well out of the roadway.

Directions: From the Mashpee Rotary (intersection of MA 28 and MA 151), follow MA 28 towards Hyannis. Take a right onto Quinaquisset Avenue and follow it for about 1.5 miles until Bryant's Bay opens up to the south. Cross the bridge over the Santuit River and park in the small lot on your left.

Crocker Neck (29)

Extending into Popponesset Bay, Crocker Neck is a real jewel—an isolated, town-owned property laced with hiking trails. From the second parking area described below, walk the remainder of the dirt road until it ends at a boat landing with a panoramic view looking westward to Popponesset Bay. The view is best on a calm evening. You can continue your exploration by taking the narrower hiking trail leading into the forest to the northeast. This path will lead through more mixed forest to some views looking eastward over an expansive marshland. Early or late in the day, if you walk quietly you are likely to run into red foxes or coyotes hunting for mice and chipmunks. You can either return to the parking lot at this point or continue farther north, to meet up with the interpretive trail. Some very tall (upwards of 8 feet) cattails line the sides of the path, which leads right through the marshland. In the right light, some rewarding landscapes can be photographed here.

Directions: From the Bryant's Bay View site, take your next right onto Santuit Road. The road will become dirt for a few hundred yards and then become paved again. Stay on Santuit,

avoiding turnoffs for other small roads. Roughly 2 miles from the bridge over Bryant's Bay, you will see the first sign: "Crocker Neck Interpretive Trail." I prefer to continue driving another half mile, turning left at the next Crocker Neck sign onto a rutted dirt track (4WD not required) and parking just before the first gate.

Mill Pond (30)

This is an idyllic little pond where European mute swans and a variety of ducks can be seen regularly (despite its proximity to two major roads). It is also a busy herring run, and the foot-long silvery fish can be seen in April making their way from the Marstons Mills River up the fish ladders to spawn in the pond. There are no hiking trails here, just a nice spot to sit and photograph the ducks, geese, and pond. Plan a visit on a still, cold morning in the autumn for the best landscape conditions. The night-cooled air will condense over the warm air of the pond and form a spooky, swirling mist over the pond. Fall foliage around the edge of the pond will provide a colorful background.

Directions: Conveniently located at the intersection of MA 28 and MA 149. There is space for six cars to park here, on both sides of MA 149.

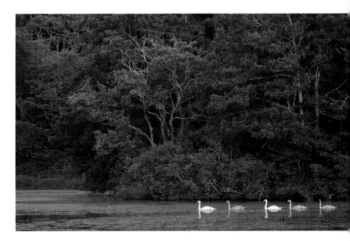

Mill Pond

Osterville Village (31)

Downtown Osterville is a network of boutique shops along a couple of petite streets sandwiched between North Bay and East Bay. It doesn't take more than 15 minutes to walk the downtown area—it's very compact. Depending on the weather, you can take photos of the shops and church, framed by seasonal flowers or blossoming trees. The best weather for town landscapes is a blue-sky day with some puffy clouds, since it is very difficult to photograph the street scenes without at least a little bit of sky. In April, the town hosts Daff O'Ville Days, a festival celebrating the arrival of the ubiquitous yellow spring flowers with events for the young and old.

Directions: From the intersection of MA 149 and MA 28, drive east on MA 28 for about 0.5 mile, turning right onto County Road. Follow County for about 2 miles into downtown Osterville.

Skunknett Brook Sanctuary (32)

This Mass Audubon Society parcel is an oasis of quiet. What makes it truly unique among Cape Cod's small public lands is the brook for which the property is named. To find the brook, take the rightmost trail fork after leaving the parking lot. The trail will pass old bogs and eventually arrive at a tiny wooden bridge. On the east side of the bridge is an open area of wildflowers and reeds, which you can use as a foreground for compositions of the brook. After working the brook (the best light is early in the day), follow the trail around West Pond. Wildflower enthusiasts will find pink lady's slipper orchids, Canada mayflower, and other small

Skunknett Brook Sanctuary

woodland flowers here from May through June. These flowers are small, so you will need either a macro lens, extension tubes, or diopters to achieve frame-filling flower portraits.

Directions: From the intersection of MA 28 and MA 149, head east on MA 28 and take a right onto County Road, then turn left onto Bumps River Road. The Audubon sign and parking area (six cars) will be on your left just after Osterville Elementary School.

JFK Memorial (33)

The John F. Kennedy Memorial is a sculptured park sited on Hyannis Harbor. There are a number of subjects to photograph here. In summer, colorful flowers surround the monument. Just south of the JFK Memorial is the statue of a soldier in honor of those who served in the Korean War. Photographing the statue from behind affords a more pleasing harbor background. Walk down to the small beach for a nice vantage of the flotilla of boats moored in Lewis Bay. Sunrise will give you nice backlight here and sunset will paint the boats with warm front lighting.

Directions: From the intersection of MA 28 and Main Street in Hyannis, head west on Main Street, then turn left onto Old Colony, followed by an immediate left onto Ocean Street. If you get lost in the confusing warren of one-way streets, follow signs or ask a passerby to point you toward the island ferries—you will pass them on your way to the JFK Memorial. Parking at the memorial is free for a half-hour or $15 at the Veterans Park entrance.

Kalmus Beach Park (34)

Directly south of busy Hyannis Harbor lies Kalmus Beach Park. This is popular sunbathing area so I visit in either in the off-season (before Memorial Day or after Labor Day) or in the early morning or late evening. Kalmus

Korean War statue, JFK Memorial site

has a narrow line of dunes, complete with brightly colored dune flowers like beach pea and beach rose. Past the dunes, a long sandy beach stretches out in an arrow-straight east-west oriented line. Keep your eyes on the sand as you walk and you may find some interesting subjects right under your feet. Bring your macro lens to capture close-ups of scallop, periwinkle, and mussel shells washed up amid the seaweed. A variety of sea birds can also be photographed here as they hunt for their meals. While beachcombing, be sure not to step on any stranded jellyfish—they can deliver a powerful sting. In recent years, Portuguese man-of-war jellyfish have infested Cape Cod waters in the summer. Their stings are extremely painful.

Directions: From Main Street in Hyannis, take a southward turn onto Ocean Street and follow it to the end. Kalmus Beach Park will be on your left at the end of the road.

Recommendations: Barnstable is rich in natural and historic photo subjects but the sites are quite spread out. A drive from Sandy Neck to Hyannis Harbor (for the JFK Memorial and Kalmus Beach Park) can take over an hour in summer traffic. Thus, you need to be careful about your planning. For example, choose to work either along MA 6A or MA 28, but not both. Whatever you choose, you should not miss the opportunity to hike at least some of the trails at Sandy Neck. The MA 6A sights are primarily natural, dominated by Sandy Neck and a handful of other smaller inland conservation lands like Bridge Creek. With a variety of trails, you can easily spend a full day at these locations. Along MA 28, heading from west to east you can visit a number of smaller sites like Bryant's Bay, Crocker Neck, Skunknett Brook, Osterville village, and the JFK Memorial.

Pro Tips: Memorial Day is not only the start of the weekend hordes, but also signals the arrival of sailboats, dinghies, and yachts—those familiar icons of the harbors. When planning a visit to a harbor like Hyannis Harbor, pay attention to the time of day and how the sun will affect the light in the harbor. In the site descriptions, I often mention that a viewpoint faces a certain compass direction. For example, at the JFK Memorial site, you are looking due east into Lewis Bay. Use this information to plan whether you will be shooting a landscape that is front-lit, side-lit, or backlit. My preferred light for shooting harbors is backlighting (meaning a morning shoot for the aforementioned Lewis Bay). This will turn the assembly of sailboat masts into an abstract silhouette of lines. The most colorful skies occur just before sunrise and after sunset, so plan to arrive at

Butterfly weed, Crocker Neck

least a half-hour before the sun's arrival or departure to catch the sun's rays lighting up the clouds from underneath.

Cautions: As the transportation hub of Cape Cod, Barnstable is also the traffic hub. Particularly on weekends from Memorial Day to Labor Day, prepare to spend a lot of time looking at taillights. Also, when hiking along beaches in the hot summer months, be sure to bring plenty of drinking water and sunscreen. The reflection of the sun off the water will fry your skin even on overcast days when the sun seems hidden.

Diversions: Barnstable County probably has the largest concentration of nonphotographic diversions on the Cape. The largest of the seven Barnstable villages is the metropolis of Hyannis. Located south of US 6, Hyannis boasts an abundance of shopping malls, restaurants, and entertainment. The Cape Cod Bay side (MA 6A) has its own collection of upscale shops—primarily art galleries, gift stores, and antique dealers.

IV. Yarmouth and Dennis Area

SEASONAL RATINGS: SPRING ★★ SUMMER ★★★ FALL ★★★ WINTER ★

General Description: Yarmouth and Dennis are quieter and more rural than neighboring Barnstable. They are also rich in seafaring history—many of the homes' original owners were sea captains. A mixture of nature trails, beach views, and architectural treasures round out the sites in this section.

Directions: Exits 7 through 9 on US 6.

Specifically: MA 6A is one of the most scenic roads you could ever find, and many of the best locations in this section—nature trails, open meadows, and boardwalks over salt marshes—are located just off of this scenic "Old King's Highway."

Historical Society of Old Yarmouth Nature Trails (35)

A mile and a half of hiking trails lead through 50 secluded acres of woodlands at this site. Start your hike by taking the dirt path to the cedar-shingled Kelley Chapel. The setting is beautiful and tranquil from late spring through fall, when the surrounding trees have full boughs of leaves. The hiking trails provide a pond view and opportunities to photograph a variety of spring woodland wildflowers. An unexpected highlight is an ancient weeping beech tree next to the Captain Bangs Hallet House. When the leaves appear in mid- to late May, walking into the tree is almost like going under an umbrella, since many of the heavy branches have drooped to resting places on the ground. Try shooting with a wide angle or fisheye lens directly upward on a blue-sky day for an unusual perspective.

Directions: Drive east a half mile from Willow Street (US 6, Exit 7) along MA 6A and turn right just before the Yarmouthport Post Office.

Where: East of Barnstable, spanning the width of the Cape from Cape Cod Bay to Nantucket Sound

Noted For: Antiques, beaches, and trails

Best Time: Late May to June and September

Exertion: Minimal to moderate hiking

Peak Times: Spring: May; Summer: June; Fall: late October; Winter: January

Facilities: At developed sites

Parking: In lots

Sleeps and Eats: Many in Yarmouthport and Dennisport

Sites Included: Historical Society of Old Yarmouth Nature Trails, Chase-Garden Creek and Gray's Beach, Swan Pond, Seagull Beach and Lewis Pond, Sesuit Harbor and Beach, Crowe's Pasture

Parking serves both the nature trails and the Captain Bangs Hallet House.

Chase-Garden Creek and Gray's Beach (36)

This is a very rewarding site that has photographic potential in almost any type of weather. The boardwalk at Gray's Beach stretches for 950 feet over the salt marsh, giving you a unique opportunity to see the marsh ecosystem without getting your feet muddy. In autumn the grasses turn reddish-gold, and under the right lighting they glow like they are on fire. A pair of osprey can be seen here starting in spring—look for the platform to your left as you walk down the boardwalk. You will need a long telephoto lens to capture portraits of birds at the nest.

The boardwalk itself makes a compelling photo subject—perfect for those leading foregrounds. Try using a wide-angle lens and explore all of the different framing possibilities. From the end of the boardwalk, the sunset

views looking westward back toward the Cape Cod Canal can be astounding. If the skies aren't compelling enough for landscape photography, this location can also be a great place for macro photography. A loop trail leads through a leafy jungle of grapevines and traverses a salt marsh. You can pick up the trail behind the kids' play area behind the main parking lot. It will immediately cross the marsh (wear waterproof boots) and then enter a forest. At the junction, take a right-hand turn. This will bring you to an overgrown section of trail—look for the big, veined leaves of fox grape. When the sun shines from behind the leaves they glow with an intense green color. At the end, you will emerge onto Center Street. You can walk back to the main lot on the road or cross the road and complete the loop on another short trail section. On quiet mornings, cottontail rabbits and many small songbirds can be found here.

Directions: From MA 6A in central Yarmouthport (just west of the junction of 6A and Union Street), drive north on Center Street until it ends at the boardwalk parking lot.

Chase-Garden Creek and Gray's Beach

Swan Pond (37)

The highlight of this petite natural area, also known as the Meadowbrook Conservation Area, is a boardwalk leading through a stand of tree trunks to the edge of Swan Pond. Your photographic subjects here include tall cattails and the skeletal remains of a grove of red cedar trees. When using the cedars as foreground subjects, be wary of merges—an undesirable condition that occurs when the branches from trees in the foreground and background overlap in the frame, appearing to touch. The end result is a more distracting, and thus weaker, photograph. Merges can be avoided by careful positioning. Nine times out of ten, shifting your position by as little as an inch can eliminate a merge. It is always a good idea to walk around and analyze the scene first before setting up your tripod so that you know all of the possibilities. Since the exposure here is southward, the pond is a worthwhile spot at either sunrise or sunset.

Directions: Take Exit 8 off US 6 (Station Avenue), turn right onto Long Pond Drive. This becomes Winslow Gray Road. Take a left onto Meadowbrook Road and follow it until it ends at the small (two to three cars) parking lot.

Seagull Beach and Lewis Pond (38)

This beach and pond are located on the Nantucket Sound side of the Cape. As you approach Seagull Beach, look left to take in the views over Lewis Pond. Numerous tiny salt ponds fringed by lush green and brown marsh grasses provide interesting subjects. You may be able to scout out some ideas for landscape shots from the car or bike, but don't park on the roadside here. Instead, continue to the large Seagull Beach parking lot and backtrack on foot. The beach itself isn't particularly noteworthy—in fact you may find more subjects while walking from the parking lot to the beach

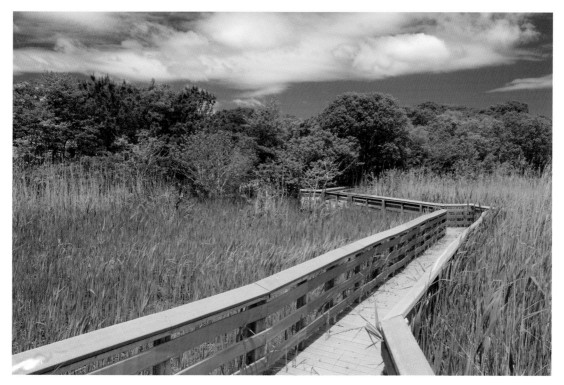

Swan Pond

than you find on the beach itself. Beach rose, beach pea, and sea lavender all provide pink accents to the dusty brown of the dunes, and the sand fences leading to the shore make great leading lines.

Directions: From MA 28 in West Yarmouth, drive south on South Sea Avenue and turn left onto Sea Gull Road. Parking sets you back $12 for the day from 8 AM to 10 PM in summer.

Sesuit Harbor and Beach (39)

Sesuit Harbor, like many of Cape Cod's pleasure-boat harbors, is a highly seasonal location. In summer, the little quays are overflowing with motorboats and sailboats. In the off-season the site is a ghost town.

Continuing to the sandy beach (also called Cold Storage Beach on some maps), pay attention to the light in the parking lot. In summer,

roughly a half-hour before sunset, the sun will sink behind the tall, grass-capped dunes, which can yield interesting shots.

Like many Cape Cod Bay beaches, the shooting opportunities vary widely with the tide. At high tide, the beach is a sandy, narrow strip between the dunes and waves. At low tide, the beach will extend nearly a quarter mile offshore. The departing seawater reveals all sorts of interesting photo subjects—sand ripples, wave-weathered stones, shells, and small sea creatures. Powerful landscape photographs require an interesting foreground and, of course, compelling lighting. Your foreground ideally should lead the viewer's eye through the scene. Keep your eyes down and stay on the lookout for sand ripples or groups of stones that make pleasing patterns for the foreground of a sweeping landscape.

Sesuit Harbor and Beach

Directions: Take Exit 9 off US 6 and drive north on MA 134. Turn right onto MA 6A and then turn left onto School Street. After a 90-degree bend, turn left onto Cold Storage Road and follow to the harbor and beach parking lots. The beach parking lot, just a few hundred yards down the road, is restricted to town stickers during the peak hours of the day (9 AM to 4 PM).

Crowe's Pasture (40)

Crowe's Pasture is a rarity on Cape Cod—a wide open meadow. This pastoral scene was far more common in colonial times, when the settlers deforested the Cape in their quest for lumber and pastureland. Then, sheep pastures and ocean views were the norm and not the exception. Today, regular mowing and controlled burning are necessary to preserve the meadow ecosystem from being overgrown by the fast-colonizing pitch pine and scrub oak woodland.

From the first parking area (just after the road turns to dirt), it's a roughly 20-minute walk through dense woodland down the Preservation Trail to reach the meadow. If you take your time on the trail, you can encounter a variety of mushrooms, especially in the fall. At the end of the trail, the landscape will open up to rolling hills carpeted with wildflowers like Queen Anne's lace and goldenrod. Continue walking down the dirt road and you will come to the marshes of Quivett Creek. From here there are two ways to access a hidden beach: a short path over the dunes or a 4WD track. At high tide, use the hulking glacial erratic boulders for seascape photo foregrounds. Due to the north-facing orientation, this beach is great for both sunrise and sunset shooting.

At low tide, you may be surprised to see a collection of plastic cages planted in the mud offshore, oftentimes with pickup trucks parked nearby. These are the growing racks for farm-raised oysters. At high tide the racks are completely submerged.

A caution: if you walk the trails from mid-October through the end of November, wear bright colors since fall quail and pheasant hunting is permitted here.

Directions: From MA 6A in Dennis, turn northward onto School Street, then take a right onto South Street and follow until you pass a cemetery on the right. The first parking area will be on your right. If you have a high-clearance vehicle, you can continue another mile along rutted dirt roads to the pasture area.

Recommendations: As in Barnstable, expect heavy traffic along the major roads here on summer weekends, especially if the forecast is for clear weather. Beaches on Cape Cod Bay and Nantucket Sound dominate the sites in this area. Try to visit beaches before 9 AM or at sunset for a chance to experience them when most of the crowds have left (although the top sunset-watching sites will still be crowded as the sun sinks below the waves). My other recommendation is to plan your photography, if your schedule permits, around the tides. The Cape and Islands have a semidiurnal tidal cycle, meaning there is a high and low roughly every twelve hours. Download a tide table from www

.boatma.com/tides. There is nothing quite like a low tide at Paines Creek Landing with the sky on fire at sunset. In contrast, when a savage storm is stirring up froth-topped waves, a high-tide shoot will make them more accessible.

Pro Tips: Are your beach scenics lacking punch? Nothing adds impact to a scene like a storm. In summer, when you are most likely to be wandering the sand, watch the forecast for thunderstorms. Rising hot air can feed some pretty strong localized thunderstorms. Unfortunately, they are not as predictable as in other parts of the country—you need to be vigilant and have your gear ready for an opportunity as the storm clears. When the sun finally breaks through, the light on the dunes or waves will contrast with the dark sky in the background to give your photo a drama that photo buyers love. An added benefit is that thunderstorms tend to clear out the beachgoing traffic. Cold fronts are another late summer treat. After they pass, the haze is washed away, leaving intensely clear skies. Make a habit of carrying a tide table and a copy of the local forecast.

Cautions: Speaking of storms, weather, and tides, be sure that when you set out for a hike that you have some basic essentials (besides photo gear, of course). Although I have never heard of anyone needing to be rescued from a hike on Cape Cod, it's certainly possible to get into sticky situations—dehydration from not bringing enough water on a summer beach hike, disoriented in a forest, or even frostbite from photographing ice floes in subzero temperatures in January. I don't want to sound like your mother, but be sure that you pack some extra layers, plenty of water, snacks, insect repellent, and, for longer hikes, a map. Lastly, don't forget to pack the most important item: common sense. If your body is comfortable then you can concentrate on the task at hand—bringing home those keeper shots.

Diversions: If you ever want to see what's on the inside of one of those historic homes along MA 6A, then visit the Captain Bangs Hallet House, next to the Historical Society of Old Yarmouth Nature Trails. This 1840 home is open for tours (beginning 1, 2, and 3 PM) during the summer and fall from Thursday to Sunday. The exhibits show how life was like for a 19th-century sea captain, featuring many artifacts and artwork.

Kelley Chapel, Historical Society of Old Yarmouth Nature Trails

V. Brewster and Harwich Area

SEASONAL RATINGS: SPRING ★★★ SUMMER ★★★ FALL ★★★★ WINTER ★★

General Description: Brewster and Harwich, like many Cape Cod towns, have spectacular ocean views, scenic harbors, and wooded parks. They also have some surprises: the best wildflower meadow on the Cape and working cranberry bogs along MA 124.

Directions: Exits 10 through 11 off US 6.

Specifically: Notable sites in this section include the oft-photographed harbor of Wychmere, the barrier beach hike of the Wing's Island Trail, the shaded trails and tranquil ponds of Nickerson State Park, and the stunning wildflowers at Thompson's Field.

> **Where:** Immediately west of the Cape's "elbow"
> **Noted For:** Cranberry bogs, beaches, parks, and wildflowers
> **Best Time:** June and October
> **Exertion:** Minimal
> **Peak Times:** Spring: May; Summer: June; Fall: late October; Winter: January
> **Facilities:** At developed sites
> **Parking:** In lots
> **Sleeps and Eats:** Many in northern Brewster (along MA 6A) and Harwich Center
> **Sites Included:** Drummer Boy Park, Cape Cod Museum of Natural History Trails, Paines Creek Landing, Nickerson State Park, Thompson's Field, Bell's Neck, Wychmere Harbor

Drummer Boy Park (41)

This compact site boasts two well-situated historic landmarks, the Higgins Farm Windmill and the Harris-Black House, both cared for by the Brewster Historical Society. In researching this guide, I visited many of the Cape's historic windmills and decided to include only this one, primarily because of its photogenic setting. Specifically, the landscaping surrounding the Higgins Farm Windmill makes it easy to get a photograph with a pleasing background free from any modern distractions like power lines or water towers. The grassy field in front of the windmill allows you to use a telephoto lens from a distance to minimize the "leaning tower of Pisa" look that plague wide-angle architecture photos. Nestled in the trees almost out of view behind the windmill is a 1795 one-room saltbox house, the Harris-Black House. As in shooting the windmill, I prefer to keep my distance and use a telephoto. This has the added advantage of compressing foreground and background, giving the feeling that the house is part of the surrounding greenery.

Directions: From US 6, take Exit 9B (MA 134). Follow MA 134 north for 3.3 miles, then turn right (east) onto MA 6A. The entrance to the park is on the north side of MA 6A roughly 2.3 miles from the intersection with MA 134.

Cape Cod Museum of Natural History Trails (42)

The Cape Cod Museum of Natural History maintains two photogenic nature trails which both depart from a convenient location off MA 6A in Brewster. Wing's Island Trail, heading northward from the museum, is one of my favorite hikes on Cape Cod. The path leads you through several interesting ecosystems: salt marsh, coastal woodland, and barrier island.

Wings Island Trail, Cape Cod Museum of Natural History Trails

Despite being only 1.3 miles long from museum to beach, it may take you a few hours to walk the entire distance if the light is good. Before heading out, check the tide tables and map, which are posted at the trailhead behind the museum. The final leg of the trail to Wing's Island is partially submerged at high tide. In general, the marsh at the start of the trail is beautiful in any season, but in particular try to visit in autumn when the grasses turn a burnt sienna color. If you take the left-hand fork of the Wing's Island Trail, you will continue to get some great views out over the marsh as you walk towards the bay. I prefer to use a telephoto for landscape shots here since it will allow you to extract the most picturesque pieces from complicated landscapes. If you time your hike to coincide with low tide, you can hike all the way to Cape Cod Bay, where a sandy beach and a veritable horde of hungry sand flies await. Sunsets can paint the sky with orange and pink hues—a spectacular sight. The photographic potential is made even better by the presence of some large rafts of cord grass that provide some foreground interest.

On the south side of MA 6A, the South Trail leads southward to marshes and woodlands. The trail begins by passing through tall stands of marsh grass and over a shallow tidal river. Herring can be seen here in springtime making their way to the ponds to spawn. Immediately after the boardwalk over the river, the trail splits—the left fork takes you on a short hike around a beech forest. The right fork continues southward roughly following the river. In mid-April, the swampy area just after the bridge is brimming with skunk cabbage. If you crush the leaves you will find out why it was so named. As the leaves unfurl in the springtime they make great studies in form and texture, especially when the late afternoon sun provides backlight. The total round-trip distance from the parking lot is 0.8 mile for the beech forest loop option or 1.5 miles for the riverside trail option.

Directions: The Cape Cod Museum of Natural History is located right on MA 6A between

MA 134 and MA 124, roughly 0.2 mile east of Drummer Boy Park. Ample parking is available on either the north or south side of MA 6A.

Paine's Creek (43)

Paine's Creek is a small but photogenic site where Stony Brook empties into Cape Cod Bay. This is a popular sunset spot in the summer (for good reason). The small parking lot will accommodate only 10 to15 cars, so plan a midweek or off-season visit to have more room for quiet contemplation. The beachscape shooting here is fantastic, particularly at low tide, when large stands of salt-marsh cord grass and a collection of tidepools are revealed. This is also a prime location for beachcombing—you can find a variety of seashells and marine critters like fiddler crabs if you look carefully. If you happen to visit at high tide or are interested in another view, you can also backtrack inland along Stony Brook for a few hundred yards and look for compositions of the brook.

Directions: From US 6 Exit 10, take MA 124 north until you hit MA 6A. Head west, then turn right onto Paine's Creek Road. Follow to the small parking lot at the end.

Nickerson State Park (44)

This large state park encompasses upland forest, kettle pond, and beach (Cape Cod Bay) ecosystems. Since the park can get crowded in summer, my favorite time to visit Nickerson is on quiet mornings in October, when the fall foliage is reflected in the many small ponds. There are a number of trails here, so before you go, visit the Massachusetts State Park website (www.mass.gov/dcr/parks/southeast/nick .htm) to download a trail map and decide where you want to explore. My favorite area is the eastern part of the park. To get there, take the eastbound road (left) to the end. Hike the trails around Little Cliff Pond and Higgins Pond, and, if you have the time, the much

larger Cliff Pond loop, where you can find rows of regularly planted white pines on the western side that make for a nice pattern repetition image. In summer, colorful piles of rental canoes and kayaks can be found on the sandy beach between Cliff and Little Cliff Ponds. Zoom in to isolate the boldly colored hulls.

The ponds can also be photogenic in the right light and weather—calm conditions at sunrise or sunset will yield the best shots. In summer and fall, the ponds are full of lily pads. Try using a telephoto to isolate groups of them with reflections of fall foliage. You may also spot bullfrogs peeping out from in between the pads. White-tailed deer are commonly sighted park residents. I usually see them along roadsides at the edges of the day. Use your car as a blind; the deer are quite accustomed to vehicles and will patiently munch away on grass while you shoot from the car, but as soon as you open the door they will bolt. Remember to turn off the car engine so that vibrations are not transmitted to your lens.

Directions: From US 6, take Exit 12, then drive westward on MA 6A for about a mile—the park entrance is on the left.

Nickerson State Park

Thompson's Field (45)

The southern portion of this property in particular is one of the best wildflower locations on the entire Cape and Islands. The property was once used as a farm and grazing area, but now is conservation land preserved for the enjoyment of all. The list of flowers you can find here is extensive. The Harwich Garden Club posts photographs of the wildflowers that are blooming, a great aid for accurately identifying what you are photographing. When you arrive, take a photo of the sign to help you identify flowers later. In midsummer, you can expect to find large swaths of bright purple chickory and glowing orange butterfly weed. Of course, pollinating all of these flowers (and hunting the pollinators) is a cornucopia of critters—butterflies, bumblebees, and spiders. Keep in mind that this is an extremely popular dog walking spot; so don't be surprised if your concentration is disturbed by a wet tongue on your leg or a slobber-covered tennis ball placed at your feet.

Directions: From US 6, take Exit 11, then drive south on MA 137, turning west (right) onto MA 39. You will pass the northern parking lot for Thompson's Field here, but I recommend parking at the southern lot. To get there, continue on MA 39 and watch for Chatham Road—you will make a hairpin left onto Chatham Road and look for the parking area for Thompson's Field about 0.5 mile down Chatham Road.

Bell's Neck (46)

This large nature area encompasses two reservoirs and a winding river that meanders through a beautiful field of marsh grasses. What I find so noteworthy about Bell's Neck is that you can take expansive panoramic landscape shots of the marshes and not worry about traces of humanity (power lines, etc.) creeping into your photos—which is very difficult to do on Cape Cod. Another huge benefit for early-morning risers is the easy access. Two dirt roads lead to parking areas near two bridges, both of which are ideal sunrise and sunset shooting locations. The western road is Bell's Neck Road (auto bridge) and the eastern is North Road (footbridge). In addition to the views from the two bridges, there are several miles of trails that lead around the marshes and two reservoirs. For a different perspective, try shooting from a kayak or canoe.

Directions: Take Exit 9 off US 6 and drive south on MA 134 (Dennis Road). Turn left onto Great Western Road and follow it into Harwich. Turn right on Depot Road and follow it south until it dead-ends at MA 28. Turn left and drive east. From here, you can take either Bell's Neck Road or North Road. Bell's

Evening primrose, Thompson's Field

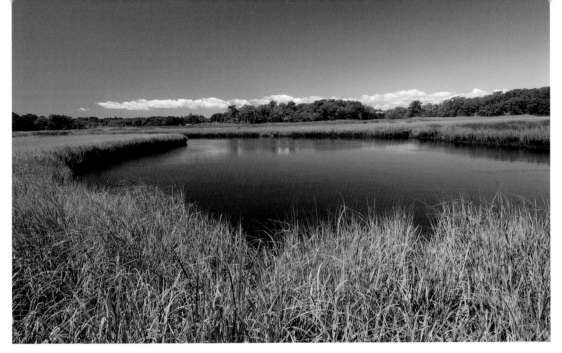

Bell's Neck

Neck Road leads directly to the auto bridge, and North Road leads to a parking area less than a minute's walk from the footbridge.

Wychmere Harbor (47)

This quaint harbor, chock-full of boats and ringed by stately mansions, is one of Cape Cod's most photographed sights, and is easily accessible right on MA 28 in Harwichport. From a small dirt pullout along MA 28, you have a commanding view over the sailboats, yachts, and fishing boats in the harbor below. The grassy knoll is a popular spot for wedding photographs, since the harbor easily can be worked into the background. Sunrise and sunset are both good times to be here; the view looks southward so the boats will be side-lit at both times. After checking out the view from MA 28, continue eastward a hundred yards and turn right onto Harbor Road. This will take you down to the pier, where you can get a different perspective and chat with the locals. Often, the catch of the day will be sitting on the pier, so you can photograph fresh lobsters or quahogs before they head off to market.

Directions: Right off MA 28 in Harwichport.

Recommendations: Begin your day in the Brewster and Harwich area with a sunrise over the marshes at Bell's Neck or the wildflowers at Thompson's Field. You will be surprised by the variety and multitude of blossoms in mid- to late summer. Arriving early (before 8 AM) will mean that you have fewer dog-walkers competing for space. If the day dawns clear, head to Harwich town center for a quick bite to eat and then drive northward to the Cape Cod Museum of Natural History. Wing's Island Trail, which heads northward through a salt marsh to a Cape Cod Bay barrier island, is spectacular in any season. At the end of the day, watch the sunset and beachcomb at Paines Creek. If autumn is in the air, check out the foliage display at Nickerson State Park.

Pro Tips: A variety of lenses are useful for

Wychmere Harbor

should be placed between your subject and the sun as close to your subject as possible. This will create a more pleasing, shadowless light for macro photography.

Cautions: Like other Cape Cod locations, it's the smallest creatures that warrant the most caution. The sand flies can be unbearable at beach locations like Wing's Island and Paines Creek, so take care when visiting these locations in late spring or summer. Ticks are often looking for a meal in the marshes, so it is important to wear light-colored clothing and to check yourself thoroughly after brushing up against reeds and tall grasses.

Diversions: Go for a paddle. Sometimes you need a break from photography. You can rent canoes and kayaks to explore the ponds at Nickerson for a modest fee. If you have your own boat, try paddling the Herring River, which twists and turns through the marshland of Bell's Neck. Should the weather turn nasty, check out the Cape Cod Museum of Natural History's exhibits to learn a little more about the natural processes that shape Cape Cod and the creatures that live here. In mid-September, Harwich hosts one of the largest festivals on Cape Cod, the Harwich Cranberry Festival. Complete with craft shows, carnivals, and concerts, this popular festival attracts about 100,000 people every year. Cranberry growers begin wet harvesting in mid-October. The process is fascinating to watch—the bogs are flooded with water and a machine is used to knock the berries off the vines. Floating booms corral the millions of shiny berries, which are finally suctioned into a waiting truck. The sea of red berries is a colorful and iconic Cape Cod image. For more information about cranberry harvesting, contact the friendly folks at the Cranberry Growers' Service (508-295-2222) for information.

these sites, from wide-angle to telephoto to macro. Use your wide-angle to capture marsh and sunset scenics at the Cape Cod Museum of Natural History trails. I recommend trying your telephoto at Nickerson to isolate small sections of the landscape, like groups of lily pads, bullfrogs on the shoreline, or stands of stately white pines. A macro lens is a good choice when heading to Thompson's Field; you can use it to capture close-up butterfly and crab spider portraits. If the sun is blazing, consider packing a small diffuser—a round, taut piece of semitransparent cloth that can be used to soften, or diffuse, harsh light. The diffuser

VI. Chatham and Orleans Area

SEASONAL RATINGS: SPRING ★ ★ ★ ★ SUMMER ★ ★ ★ ★ FALL ★ ★ WINTER ★ ★ ★

General Description: The Cape's elbow is a unique place—part working fishing village, part exclusive resort. The mixture makes for a fun-loving place with lots of subjects for the photographer.

Directions: To get to the Chatham sites, take MA 137 south from US 6 to MA 28. Turn left and follow MA 28 eastwards to the rotary in the middle of Chatham. Orleans is impossible to miss—it's accessible from US 6 Exit 12 or off the large rotary where US 6 takes a 90-degree turn northwards.

Specifically: Chatham has a concentration of unique photographic subjects in a very small area—a seal colony, broad sandy beaches, two photogenic lighthouses, and an active fishing fleet. Orleans has sandy beaches, a Cape Cod Bay harbor, and a quiet nature area on Pleasant Bay.

Fish Pier (48)

Longliners, trawlers, and lobstermen call this small but active fishing port home. The fishing boats depart well before dawn and return with their catch, which includes haddock, cod, flounder, pollock, dogfish, halibut, and lobster,

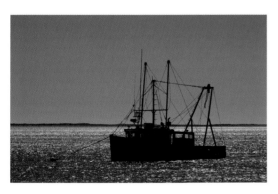

Chatham Fish Pier

Where: The Cape's "elbow"—the southeastern corner
Noted For: Fishing, birding, seals, lighthouses, beaches, and a fancy downtown area
Best Time: June and October
Exertion: Minimal
Peak Times: Spring: May; Summer: June; Fall: late October; Winter: January
Facilities: At developed sites or in town
Parking: In lots
Sleeps and Eats: Many in Chatham town
Sites Included: Fish Pier, Chatham Lighthouse, Monomoy National Wildlife Refuge, Seal cruise, Stage Harbor, Hardings Beach and Stage Harbor Light, Rock Harbor, Kent's Point, Nauset Beach

starting around noontime. Early afternoon is a great time to hang around the pier waiting for the catch to come in. You can photograph the entire unloading process from the observation deck. Even if you miss the fishermen working, there are always boats moored here and vibrantly colored fishing paraphernalia like nets and buoys. Since the harbor is east-facing, sunrise will give you backlight, rendering the moored fishing boats as silhouettes.

Directions: Follow Main Street through downtown Chatham until it ends at Shore Road. Turn left and drive north for 0.5 mile, then look for the pier parking on your right. Park in the upper lot only; the lower lot is reserved for the fishermen.

Chatham Lighthouse (49)

A lighthouse has warned ships away from the dangerous islands and shoals here since 1808. The present tower and keeper's house, now

owned and operated by the United States Coast Guard, is more substantial than the original wooden structures. A chainlink fence keeps visitors at bay, so shooting angles are unfortunately limited.

After photographing the lighthouse, turn around and check out the view over the surf from the parking lot. From the 50-foot-tall bluff, it is a sweeping view eastward out over the sand bars to the open Atlantic Ocean. If you come here before sunrise, I guarantee you the parking will be easier than at noontime and you may also be rewarded with glowing sunrise color.

Directions: From downtown Chatham, follow Main Street to Shore Road, then turn right (southwards). The lighthouse is less than 0.5 mile down the road; you can't miss it. The parking area (on the left) is quite small and the spaces are limited to a half hour. If you would like more time to explore the beach area, I sug-gest parking in town and walking to the beach and lighthouse.

Monomoy National Wildlife Refuge (50)

This huge area encompasses over 7,000 acres of barrier islands (North and South Monomoy) and the peninsula of Morris Island. The refuge is one of the top birding locations on the East Coast—a site honored with a designation as a Western Hemisphere Shorebird Reserve Network regional site. Morris Island peninsula is accessible by foot, and the rest of the reserve—North and South Monomoy Islands—is accessible only by boat.

Your first taste of the refuge is the Morris Island Trail, which begins just to the left of the refuge headquarters. Be sure to check the tide tables before you start the hike, because the first portion of the trail, along a narrow sand beach at the foot of a tall riprap barrier, is underwater at high tide. The trail leads along the beach and then loops back through the marshes to return

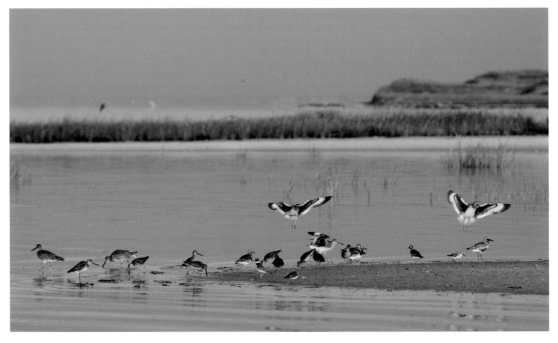

Shorebirds, Monomoy National Wildlife Refuge

to the parking lot at the refuge. Birds of all feathers (literally hundreds of species) stop here to feed and breed. In late summer, it's not uncommon to find whimbrels, piping plovers, and common terns all feeding and scurrying along the tide's edge. Use a long telephoto lens (400mm and up) to avoid disturbing the birds. Check with the refuge staff to find out what species have been sighted recently. In addition to the birds, you can find all sorts of interesting subjects along the water's edge if you walk slowly. The primordial horseshoe crab is abundant from spring through late summer. Even if the crabs aren't around, you will see a lot of empty cast-off shells on the beach. In addition, scallop and spider-crab shells can be found along these beaches—their shape and textures make them first-rate macro subjects.

The islands of North and South Monomoy are accessible only via day-trips through the Mass Audubon Wellfleet Bay Wildlife Sanctuary (www.massaudubon.org/wellfleetbay) and commercial ferry operators like Outermost Harbor Marine (www.outermostharbor.com). See the next entry for more information on boating tours. I prefer to shoot at Morris Island because the island boating trips don't start running until 8 AM, well after sunrise most of the summer. However, if you're a hard-core bird photographer you should definitely get over to the islands to see the big aggregations during the day.

Directions: From Chatham Lighthouse, continue south, taking a left turn onto Morris Island Road. Take your first right (still Morris Island Road) and follow signs to the Monomoy National Wildlife Refuge Headquarters (on the left).

Seal cruise (51)

The Monomoy Island National Wildlife Refuge seal tours, currently offered by Outermost Har-

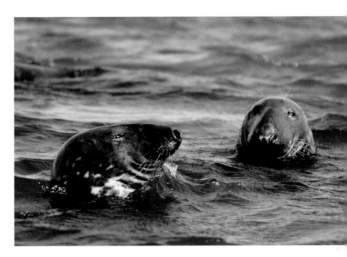
Gray seals

bor Marine (www.outermostharbor.com), the Monomoy Island Ferry (www.monomoy islandferry.com), and the Wellfleet Bay Wildlife Sanctuary (www.massaudubon.org/massbay), are a worthwhile and entertaining trip, regardless of whether you actually manage to get any good photographs. You can see harbor seals (identified by their dog-like heads), gray seals (much larger, with elongated, horse-like heads), and occasionally young harp seals (a more northerly species with large spots on the sides).

The boat companies run short (one hour) tours around the known seal hangouts but they do not stop. Shooting any subject from a small moving boat is a challenge. Trying to catch seal heads popping up with a telephoto lens is particularly difficult, since by the time you swing the lens around and locate the seal head, it has usually disappeared beneath the waves. My patented technique is to use a moderate telephoto zoom (70 to 300mm) and have it in hand, at eye level, when you start seeing heads appearing in the water. Keep both eyes open, and be ready to aim and push the release the second a head appears in your field of view. Don't swing the camera around crazily trying

to catch every head you see—seals are fast and you'll have a hard time catching them with that method. Of course, if you're lucky, you'll see a whole pile of sausage-like seals hauled out on the sand sunning themselves. You never know what the seals will be doing until you get there, although you can call the tour companies to get an idea of what the viewing has been like. There are also ferries that will leave you on South Monomoy for a bit of time. Keep in mind that there are strict regulations governing how close you can approach the seals. You need a permit from the Monomoy National Wildlife Refuge Manager to photograph seals from the beach (www.fws.gov/northeast/monomoy; 508-945-0594).

Directions: Visit the websites of Outermost Harbor Marine (www.outermostharbor.com) and the Monomoy Island Ferry (www.monomoyislandferry.com) for directions to their parking areas and schedules.

Stage Harbor (52)

Harbors don't get much quainter than this. Fishing boats, sailboats, and motor yachts all share this small network of piers. Start at the small bridge overlooking the Mitchell River and shoot southward. From here, you will easily be able to take in the collection of boats with a moderate wide-angle or normal lens. Next, move onto the piers and work some close-ups of the fishing gear itself—buoys, lines, nets, colorful hulls, and reflections. The shooting is rewarding here in almost any weather, but the atmosphere is particularly moody in a thick fog. Sunset and sunrise are predictably stunning, especially if the water is serene enough to hold the reflection of a colorful sky. This is also a productive place to visit at noontime on a sunny day, when the light might be too washed out for landscape or macro photography. Focus on the boat hull reflections, zooming in with a telephoto to exclude the sky if it's hazy and uninteresting.

Directions: From the intersection of Main Street and Old Harbor Road in Chatham, turn right and drive south on Stage Harbor Road, then turn left onto Bridge Street. Park on the north side of the road to the west of the bridge.

Hardings Beach and Stage Harbor Light (53)

Hardings Beach is a long sandy beach stretching out into Nantucket Sound. The beach is well positioned for sunset shooting, since the angle of the beach is roughly northwest to southeast. I recommend taking the 15 to 20 minute hike along the dunes to the lighthouse. Stage Harbor Light is a diminutive lighthouse set amidst rolling sand dunes a few hundred yards from the ocean. The light is best at the edges of the day; be sure to bring a headlamp or flashlight so you're not caught in the dark on your way back to the car.

Directions: From Main Street in Chatham, drive south on Barn Hill Road (across from the airport), then take the right-hand fork for Hardings Beach Road and follow it until the end.

Rock Harbor (54)

This popular harbor on Cape Cod Bay in Orleans is an idyllic spot for photographing Cape Cod nautical charm. Focus on the brightly colored lobster buoys hanging on the side of the Captain Cass Rock Harbor Seafood Restaurant or wander around the pier for shots of sport fishing boats, tall pilings, and seafarers of all varieties. The beach beyond the harbor is also a good sunset location, particularly at low tide when you can walk way out into the bay.

Directions: Take Exit 12 off US 6 and proceed northeast on MA 6A. Turn left onto Rock Harbor Road, which will lead you directly to the harbor.

Hardings Beach and Stage Harbor Light

Kent's Point (55)

This quiet natural area is a real hidden gem of the Lower Cape. A series of walking trails takes you to some beautiful views of Pleasant Bay. From the parking lot, follow the broad trail to the end of the peninsula and then poke around the shoreline to see what photo subjects you find on the beach. In summer, tall sailboats sit at their moorings in the quiet waters. The tiny pink flowers of sea lavender bloom amid the cord grass in late August. Be aware that this is a popular dog-walking location; don't be surprised if a furry friend jumps into your composition unexpectedly.

Directions: Take Exit 12 off US 6 and proceed northeast on MA 6A. Turn right on Main Street and cross MA 28. Turn right onto Monument Road, then left onto Frost Fish Lane. Follow the green "Kent's Point" signs to the end, where there is a large dirt parking area and a trail map on display.

Nauset Beach (56)

If you like your ocean wild and untamed, Nauset Beach is the place for you. When nor'easters whip things up, Nauset Beach gets blasted by pounding surf. Even if the weather is fair, storms far offshore can generate waves that eventually make landfall here. Be prepared to encounter some of the tallest waves on Cape Cod. If you arrive at or before sunrise, the sun will come up just over the wave crests and provide intense backlighting. On particularly windy days, you can also photograph surfers riding the waves. If you need to escape the crowds, just start walking up or down the beach and within 15 to 20 minutes, the waves will be your only company. If you run out of inspiration, try this technique. Looking down the beach, set your shutter speed to 1/15th of a second and pan with the waves as they advance on the shore. With practice, you'll be able to capture some impressionistic photographs.

Nauset Beach

This method works better with a digital camera since you can review your results and adjust your settings accordingly.

Directions: Follow Main Street eastwards through Orleans and take the left fork onto Beach Road. Follow it until it ends at the large Nauset Beach parking area.

Recommendations: Chatham and Orleans boast a variety of photographic subjects all within close reach of each other. Not only that, but if the weather is uncooperative, the towns have interesting shops. If you have only one day and you want to make the most of it, start before dawn at either Nauset Beach or Chatham Light. At Nauset, you can catch the big rollers hitting the shore. At Chatham Light, shoot sunrise over the sands stretched out before you and turn around to watch the warm morning light paint the lighthouse itself. After the sweet light has faded, explore downtown Chatham or the Stage Harbor area. After a lunch break, don't forget to spend time at the exciting fish pier to watch the catch coming in. Finally, finish the day at Hardings Beach or Rock Harbor for a sunset shoot.

Pro Tips: Shooting active subjects like seals and fishermen may require you to detach from the tripod. Although this may rob you of some sharpness, it does allow for more fluid compositions and give you the ability to react quickly. For the best handholding results, keep your elbows pinched inward and use your hands to cradle the camera and lens from beneath. Push the camera backwards into your forehead to create a makeshift brace with your body. Alternatively, use the camera strap as a brace. With the strap around your neck, shorten the length by winding the excess around your hands. The tight pull of the strap on your neck should feel similar to the forehead push technique and have the same effect. You could also use any nearby stationary objects to brace against, such as a nearby lamppost or stone wall. However, when shooting from a small boat, don't use the boat as a brace since the boat's motion and engine vibrations will be transmitted to your camera.

Cautions: You should be familiar with beach cautions by now, and they can be extended to shooting from a small boat. Salt spray will be even more prevalent on the open water, especially if you're traveling at speed. Wait until the boat slows down before getting out your equipment, and be sure to watch for waves coming over the railings. If you have a roll-top dry bag like kayakers use, keep your camera gear stowed when the boat is moving.

Diversions: The town of Chatham offers an enticing opportunity to sample some of the Cape's finest restaurants and shopping. Beautifully maintained historic homes line the small streets. The town is an enjoyable place for an afternoon break while waiting for the evening light. Have some chowder and check out a bookshop. A wise photographer peruses the postcard rack to see what shots have worked for others.

VII. Eastham and Wellfleet Area

SEASONAL RATINGS: SPRING ★ ★ ★ ★ SUMMER ★ ★ ★ ★ FALL ★ ★ ★ WINTER ★ ★

General Description: Since these towns straddle the width of the peninsula, Eastham and Wellfleet have beautiful beaches and harbors on both Cape Cod Bay and the Atlantic Ocean. Eastham's top sites include First Encounter Beach, Nauset Light, and the Fort Hill area. Wellfleet has a high concentration of top-rated photography locations packed into a small area—a charming town center and active fishing pier complement stunning natural scenery along the Cape Cod Bay and Atlantic coasts.

Directions: Off US 6 north of the Exit 13 rotary.

Specifically: There is a lot to hold photographers here—several of these spots are listed as my favorites (see Section XI for more). First Encounter Beach is my top sunset location, while the Great Island Trail is one of the most scenic hikes on the Cape and Islands. Wellfleet town pier is a lively place to photograph old boats and old salts.

> **Where:** Midway up the Cape's "forearm"
> **Noted For:** A big stretch of the Cape Cod National Seashore, spooky swamps, and Wellfleet oysters
> **Best Time:** June and September
> **Exertion:** Minimal to moderate hiking
> **Peak Times:** Spring: May; Summer: June; Fall: late October; Winter: February
> **Facilities:** At developed sites
> **Parking:** In lots
> **Sleeps and Eats:** Many in the town of Wellfleet, more along US 6
> **Sites Included:** Maple Swamp, Fort Hill, First Encounter Beach, Salt Pond Visitor Center Trails, Nauset Beach Lighthouse, Three Sisters Lighthouses, Wellfleet Bay Wildlife Sanctuary, Atlantic White Cedar Swamp, Cannon Hill, Wellfleet Town Pier, Great Island Trail, Duck Harbor

Maple Swamp (57)

The well-maintained trails near the Fort Hill area lead you to a gold mine of natural subjects at this maple swamp. After a short walk past a meadow of summer wildflowers, butterflies, and some extremely persistent deer flies, you find yourself in a green oasis. Boardwalks lead you past old maple trees encrusted with grapevines. Tall cinnamon and netted chain ferns carpet the boggy earth to the sides of the boardwalk. Large bullfrogs can be found here—visiting in early morning will find them sluggish, willing photo subjects. Thick forests like this are best photographed in overcast or foggy conditions, when the contrast is more manageable for film or digital sensor. Continuing out

Maple Swamp

of the swamp, you can also get some panoramic views northeastward over the marsh at Sharpening Rock, a glacial erratic boulder that was used by native people to sharpen their primitive tools.

Directions: Heading north on US 6 in Eastham, take a right onto Governor Prence Road. Turn right onto Fort Hill Road and park at the small lot on the left hand side of the road opposite the Captain Penniman House.

Low tide, First Encounter Beach

Fort Hill (58)

Fort Hill is one of my favorite sunrise spots on Cape Cod. The narrow winding road takes you to the top of a hill (at altitude of roughly 100 feet, mountainous by Cape Cod standards). Another unique Cape Cod feature is the field leading to the marshes. Not so long ago, the entire Cape once looked like this—the first European settlers felled most of the trees for building and converted the land to pasture. As farming was replaced by other industries on the Cape, the trees recolonized. The gently sloping field leading down from Fort Hill, however, has been maintained as a meadow. This makes it an important habitat for field-loving birds like bobolinks and swallows. In spring the bird song is almost deafening. The views from the hill are impressive, but a thin line of trees at the base obscures the unfolding network of marsh to the east. My advice is to walk along the path at the base of the hill and look for spots to shoot eastward as the sun rises over the marsh.

Directions: Follow the directions for the Maple Swamp, but continue up Fort Hill Road to the small (10 cars) parking lot at the end.

First Encounter Beach (59)

When a low tide coincides with sunset, come here for beach landscape photography at its finest. From the parking area, Cape Cod Bay spreads out before you. The departing sea leaves a treasure to explore and photograph. Tiny hermit crabs crawl about busily in the tide pools. Sand ripples stretch out in graceful fans from the clumps of bright green cord grass. When shooting landscapes here, I often use the repetitive lines of the sand ripples to lead the viewer into the composition. By using a wide-angle lens and angling it downward, you can give your photograph a feeling of depth, almost like you are inviting someone to walk into your

scene. As the sun sets, the shadows will get longer and more dramatic. I prefer to start shooting here about two hours before sunset and continue to a half-hour after sunset. Two words of caution: in some spots the sand will give way to clingy soft mud, which can literally rip the sandals right off your feet. If you get into a spot like this, back up and pick another route or you're risking the loss of your footwear. Second, when the air is still the sand flies will be out en masse. Only Zen-like patience will allow you to keep shooting in these conditions.

Directions: From US 6 in Eastham, turn west on Samoset Road and follow to the end.

Salt Pond Visitor Center Trails (60)

The National Park Service Salt Pond visitor center features two trails for different hiking abilities: the small, but informative, Buttonbush Trail (0.25 mile) and the longer Nauset Marsh Trail (1 mile). If you have time, walk both of the trails since they will give you completely different photographic subjects. The Buttonbush Trail takes you past a small pond and inland forest. Interpretive trail markers will help you identify the species of trees and plants. The highlight is a boardwalk over a small pond full of buttonbush, a thick bush that sprouts fluffy white flowers in late summer. The longer Nauset Marsh Trail takes you around a salt marsh pond and then provides expansive views out over Nauset Marsh, before heading inland and returning to the parking lot.

Directions: You can't miss it. Turn east onto Nauset Road at the big National Seashore sign on US 6 in Eastham. The visitor center is located immediately on the right.

Nauset Beach Lighthouse (61)

Like many of Cape Cod's lighthouses, this one has been moved inland from its original position in order to save it from shoreline erosion.

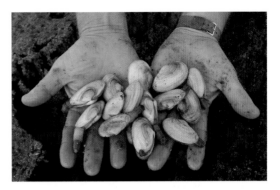

Farmed steamers, First Encounter Beach

In 1996, Nauset Light was a mere 36 feet from the edge of the cliff. A group of concerned citizens, the Nauset Light Preservation Society, stepped in to save this historic landmark. The lighthouse is now situated a few hundred yards inland, among the pitch pines. Your first view will be from the large Nauset Light beach parking lot. An array of power lines interferes with your view here, so I recommend shooting the lighthouse from the north side. I prefer to use a telephoto here to zoom in on pieces of the lighthouse, like the windows and red and white paint against a blue sky, since the foreground is not very appealing. The Nauset Light Preservation Society runs tours of the lighthouse on Sundays from May to October. For details check www.nausetlight.org.

Directions: From the Salt Pond visitor center, continue east on Nauset Road, which will become Doane Road. At the end of the road, turn left onto Ocean View Drive and turn right into the large beach parking lot at the end of the road.

Three Sisters Lighthouses (62)

Like their bigger brother, Nauset Lighthouse, this trio of lighthouses was also relocated westward to escape shoreline erosion. The structures can be reached by a 10-minute walk on a path along Cable Road from the Nauset Light

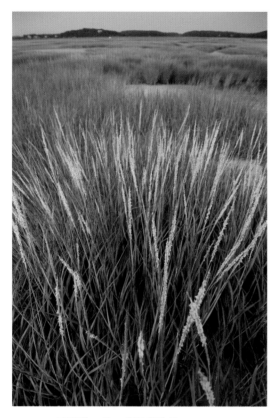

Wellfleet Bay Wildlife Sanctuary

beach parking area. The setting is a forest-ringed grove. As such, the best time to shoot the lighthouses is on a foggy day in spring or summer when the trees have their leaves. Like any forest subject, this is a difficult if not impossible shot on a sunny day because the dappled light filtering through the trees creates too much contrast.

Directions: From the Nauset Beach Lighthouse, drive west down Cable Road. A small pull-off on the right accommodates two or three cars.

Wellfleet Bay Wildlife Sanctuary (63)

This Mass Audubon site is diverse and subject-rich, with something for every kind of nature shooter. The trails are well marked and maintained and the facilities are top-notch. The sanctuary offers a plethora of naturalist-guided outings, including birding trips and boat trips in Nauset and Chatham.

Start your exploration at the visitor center. The staff know every inch of the property and will happily point you to the best photography spots. Read the logbook to see what animal and bird life other visitors have encountered in the last few days. The trails on this 800-acre property lead to a variety of Cape ecosystems. The Silver Spring Trail leads to a freshwater pond. In summer, painted turtles can be photographed as they sunbathe on logs. Bullfrogs and other amphibians hide in the shallows—approach them slowly to minimize your impact.

Follow the Goose Pond Trail next—it will take you first to a bird blind, where you can photograph some of the 250 different species of birds that have been seen here, from kestrels to red-tailed hawks.

If you like landscapes, you will find stunning salt marsh views out to the edge of Cape Cod Bay (when the tide is out) from the Try Island and Bay View trails. You can shoot wide-open landscapes of the green patchwork quilt of marsh grasses and tide pools or close-ups of fiddler crabs. In summer, beware of greenhead flies; their bloodsucking bites are painful and their tenacity makes it hard to concentrate on photography.

Directions: The sanctuary is a well-marked westward turning off US 6 just before the Wellfleet and Eastham town border. The gates are closed from sunset to 8 AM. The fee for adults is $5 for nonmembers, free for Mass Audubon members.

Atlantic White Cedar Swamp (64)

The National Seashore parking area for the Marconi Wireless Station brings you to two very different photography sites. The first is the wireless station—a small informative dis-

play honoring the place where the first transatlantic wireless communication took place in 1903. From the 40-foot-tall bluff, you can appreciate the Atlantic Ocean stretching out before you. A panoramic camera or digital photo-stitching program will help convey the grandeur of the scene.

On the landward side of the parking lot, a seldom-crowded 1.25-mile trail leads to the Atlantic white cedar swamp, one of my favorite locations for introspective, quiet landscapes. It feels like you have been transported to a southern bayou—the trees, with their crooked branches draped in mosses like green beards, stand eerily in the tea-colored water. Photography is best on a cloudy day, when the contrast is low and the many shades of green and brown come alive. In summer, prepare to be swarmed by flying insects. This is, after all, a swamp, and a prime breeding ground for mosquitoes and deer flies. Without serious bug protection, you will be lucky to get a glimpse of the stately Atlantic white cedars as you sprint down the boardwalks. If you visit in April or late September, the bugs are a memory and it becomes a magical place.

Directions: Follow signs for Marconi Beach Road, east of US 6 in Wellfleet, to reach the Marconi sites. Make sure to take the left fork (Marconi Station Road) to access the swamp trail. The right fork takes you to Marconi Beach.

Cannon Hill (65)

In the heart of Commercial Street in Wellfleet, a rickety wooden bridge called Uncle Tim's Bridge leads to a small plot of land that the town has preserved as a green space. Walking around the spit of land, you will find scenic views of both the salt marshes and harbor. The

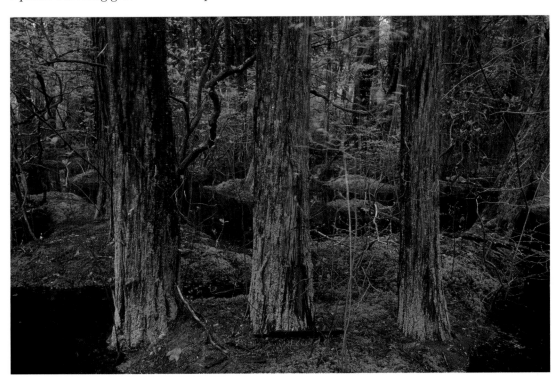

Atlantic White Cedar Swamp

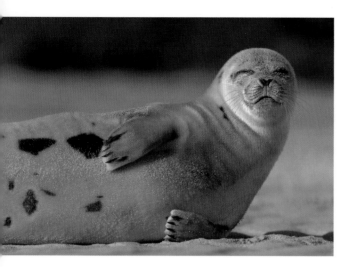

Juvenile harp seal, Great Island Trail

bridge itself is one of the best photographic subjects in the area.

Directions: From the Wellfleet Center turnoff (traffic lights) on US 6, follow Main Street to a fork, then take the left hand turn onto Commercial Street. You'll see Uncle Tim's Bridge on your left. There is parking for only two cars here, although it's not a long walk from the fishing pier, where there is ample parking.

Wellfleet Town Pier (66)

The town pier could be considered the "hub" of Wellfleet. Both an active fishing fleet and a thriving shellfish farming industry operate here. Mac's, a popular fried-seafood restaurant and ice cream parlor right on the pier, makes this a popular place for people of all ages to hang out. The pier area is quite large, encompassing not only the working fishing boats but also a sprawling recreational boat pier. It's a busy spot throughout the summer, with boats and boaters coming and going. There are tons of things to photograph, from fishing boats and gear, to the fishermen bringing home the catch, to young kids casting their lines. Sunset is a great time to be here, especially in summer when the pier

is full of people. Of course, I should also mention that photography is more productive with an ice-cold frappe (a peculiar New England name for a milkshake) from Mac's.

Directions: From Cannon Hill, continue down Commercial Street to a 90-degree bend. The town pier is straight ahead.

Great Island Trail (67)

Like Sandy Neck in Barnstable and the Provincelands dunes in Provincetown, the Great Island Trail is a taste of "wilderness" on Cape Cod. Out and back, the trail runs for 8 miles—along salt marshes, sandy beaches, and through forests of pitch pine. Stretching southward like a finger along the Cape Cod Bay shoreline, Great Island is technically not an island, but a tombolo, a bar of sand joining an island to the mainland. Jeremy Point, the final destination of the trail, can be reached only at low tide. This is a trail I have returned to time and again, through every season—one of my very favorite spots on Cape Cod.

From the parking area, you will descend through a forested area and emerge on the edge of a marsh. You can photograph fiddler crabs here—look for their holes in the mud. After crossing the marsh, you will come to a split in the trail. Take the left fork for a more circuitous route along more of the marsh or choose the right fork to proceed directly over a headland. Since both routes have interesting subjects, I usually take the left fork heading southward and return via the direct route. If you take the left fork, you will hike along a salt marsh and may come across the bones or carcasses of pilot whales. Because of the narrow inlet that the Great Island peninsula forms with the mainland, schools of pilot whales frequently beach here, and their skeletons now decorate the marsh grasses. As you continue southward, a number of interesting landscape compositions will appear. The sand dunes are tall and pro-

vide a vantage point to look out over the spit of land that ends at Jeremy's Point (visible only at low tide). If you time your hike well, you can photograph sunset over the bay before hopping in the car. You can easily spend an entire day at this site, so don't forget snacks and plenty of water.

Directions: From the town pier, drive westward on Kendrick Avenue, which will become Chequessett Neck Road. Follow this over a small bridge and then look for a left turn into the parking area for the Great Island Trail.

Duck Harbor (68)

At first glance, the beach at Duck Harbor seems no different from any of the other Cape Cod Bay beaches. If you take a 15-minute walk southward, though, you'll see why I consider this a unique area. A 60-foot-tall sand dune rises up from a sea of beach grass. In the late afternoon, the setting sun will paint the dune face with rich golden hues. A trail allows you to photograph from both the base and crest of this imposing wall of sand. On the way, look for interesting patterns and rock formations on the beach. Use the lines to lead the viewer into the frame, and cap it off with a colorful sunset over the bay waters. Because of the large contrast range between the sand and bright sky, I recommend using a split-graduated neutral density filter to balance the exposure. It will result in a brighter foreground and punchier colors in general.

Directions: From Chequessett Neck Road in Wellfleet, near the Great Island Trail parking area, take a right-hand turning onto Griffin Island Road. Follow this until it ends in a dirt parking lot at Duck Harbor.

Recommendations: The Eastham and Wellfleet locations are all worthy of extensive exploration, so if you can, devote more than a day to this image-rich destination. Start before dawn

at either Fort Hill or Nauset Light Beach to capture the sun rising over the marshes or breaking waves, respectively. Next, check out the depths of the Atlantic white cedar swamp or have an early lunch in Wellfleet. Spend the afternoon hiking the trails and exploring the lighthouses at the Cape Cod National Seashore, then finish off with a sunset at First Encounter Beach or the Wellfleet town pier. Alternatively, pack a picnic lunch and spend the morning and afternoon exploring the Great Island Trail. That hike could be combined with a sunset shoot at Duck Harbor for a full day of nature photography. Needless to say, you can't go wrong wherever you choose to photograph here.

Pro Tips: Visit the beaches, especially Atlantic Ocean beaches like Coast Guard Beach and Nauset Light Beach, in the early morning or late afternoon to avoid both the sun's scorching rays and the scorching parking fees. Usually, no parking fees are charged before 10 AM or after 4 PM, which works out perfectly for photographers. Nature shooters can expect to encounter anything and everything at the natural sites, so pack as much as you can comfortably carry. Tiny fiddler crabs will beg for a macro lens and dune scenics will cry out for your wide-angle. The chance of finding seals or foxes along the beaches will necessitate a telephoto in the 300mm–400mm range. More important than camera gear is an alarm clock. Making it out of bed in time for a Fort Hill sunrise takes quite a commitment, since sunrise can be as early as 5 AM on the summer solstice.

Cautions: The Atlantic beaches are known for their waves, and these watery behemoths can spell disaster for the unwary photographer. If you are photographing close to the surf, always be aware of your footing and keep an eye on the incoming waves. I have heard more than one tale of an unsuspecting photographer getting

drenched by an unusually tall wave. A salt-water soaking will mean a lot more damage than wet feet—salt is extremely corrosive and your camera may be irrevocably damaged. Play it safe and keep your distance.

If you're heading off to the Great Island Trail or the Wellfleet Bay Wildlife Sanctuary, make sure you bring plenty of food and water. There is nothing worse than watching a spectacular scene unfold while your stomach makes endless complaints. In summer, hiking along the sand can tire your muscles and dehydrate you extremely quickly, so bring twice as much water than you think you will need and half as much camera gear. It takes concentration to make art, and you shouldn't be worried about thirst or hunger pangs.

Diversions: After your sunrise shoot, rent a bike and cruise down the Cape Cod Rail Trail, a 22-mile track that begins in Dennis and ends in Wellfleet. The slower pace makes you notice scenery that you might not otherwise appreciate from a speeding car. Plus, it's a great way to relax and avoid the traffic. Then you won't feel so guilty when you order that ice cream sundae after dinner. For a relaxed evening of entertainment, try Wellfleet's drive-in movie theater along MA 6 (on the Eastham-Wellfleet line), always a treat for adults and kids alike. Another notable diversion is Wellfleet's large collection of art galleries. I highly encourage you to check out the works of local artists on display—they will inspire you to get out there and make some art of your own.

Duck Harbor

VIII. Truro and Provincetown Area

SEASONAL RATINGS: SPRING ★★★ **SUMMER** ★★★★ **FALL** ★★★ **WINTER** ★★

General Description: Truro and Provincetown lay claim to some of the Cape's wildest natural areas—the expansive rolling dunes and windswept beaches of the Provincelands. The town of Provincetown, commonly shortened to "P-town," can lay claim to being the Cape's wildest urban place—a fun town to wander around with an open mind.

Directions: Follow US 6 eastward and northward until it ends.

Specifically: Visit the massive rolling dunes at Head of the Meadow or the Provincelands, then check out the shops, streets, and the vibrant culture of P-town.

Pamet Harbor (69)

This Truro town boat landing is located at the confluence of the Pamet River and Cape Cod Bay, making it an outstanding sunset spot. In summer, the harbor is filled with yachts, dinghies, and sailboats. This is a much better high-tide location for photography, since at low tide many of the dinghies will be stranded in the mud. At low tide, try to get further south to a beach like Duck Harbor in Wellfleet or First Encounter Beach in Eastham.

If you come at high tide, you will be able to get shots of dinghies in the foreground with the harbor and setting sun in the background (bring a tripod). A split-graduated neutral density filter will be handy here to balance the exposure difference between the dark foreground and the much brighter background. Don't forget your bug spray; the sand flies can be persistent on calm evenings.

Directions: From US 6 in Truro, take the Pamet Roads exit, loop around and head west under US 6. Then take a left at the T, followed

> **Where:** The Cape's fist, the literal "end of the road"
> **Noted For:** Lively and diverse "P-town," orderly cottages and rolling dunes
> **Best Time:** July and October
> **Exertion:** Minimal in town, moderate to difficult when hiking on sand
> **Peak Times:** Spring: May; Summer: late June to July; Fall: October; Winter: February
> **Facilities:** At developed sites
> **Parking:** In lots or roadside in towns
> **Sleeps and Eats:** Truro (campgrounds, cottages, and beach houses) and Provincetown (everything)
> **Sites Included:** Pamet Harbor, Highland Lighthouse, Head of the Meadow Beach, Days' Cottages, Provincelands dunes, Beech Forest Trail, Race Point Lighthouse, MacMillan Wharf, Commercial Street Provincetown, Long Point

by a right onto Depot Road. Stay right at the fork (still Depot Road) and you will end up at the harbor.

Highland Lighthouse (70)

Highland Light, also known as Cape Cod Light, sits on a tall bluff bordered by the greens of a golf course. Highland is known for its beacon—the most powerful of any lighthouse in New England. The postcard-perfect tower and keeper's cottage were built in 1857 (though a light has been in operation here since the 18th century). A series of wooden fences are kindly provided for photographers to use for leading foregrounds. A short walk will take you beyond the lighthouse to the edge of the cliff (where the lighthouse used to stand before being relocated to safety). The view from the cliff edge is

limited; you won't be able to compose shots with lighthouse and ocean unless you own (or rent) a small plane. However, that's not to say you can't get some great shots of the lighthouse. Come on a blue-sky day with some puffy clouds for a bright cheery background.

Directions: From US 6 in Truro, take eastbound Highland Road, then a right onto South Highland followed by an immediate left onto Ocean Bluff Lane. Follow it to the parking lot.

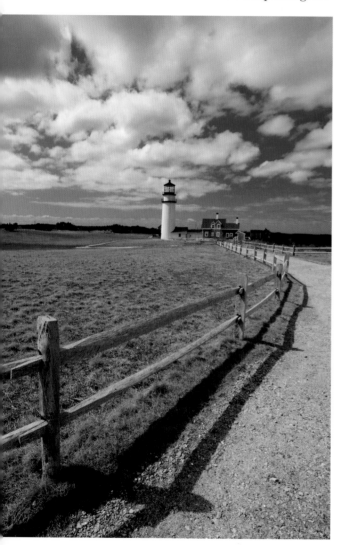

Highland Lighthouse

Head of the Meadow Beach (71)

This broad Atlantic beach is one of my favorite sunrise locations. From the parking lot, you will be looking up at 50-foot-tall dunes—nature's protection from the encroaching sea. My favorite time here is before dawn, when your car will be the only one in the lot and the beach will be hauntingly beautiful in its emptiness. On several occasions I have encountered over a dozen gray seals (distinguished from their smaller cousins, the harbor seals, by their large horse-like heads) frolicking less than 50 yards offshore. In summer, white lifeguard chairs will stand like silent statues along the beach.

Both the quiet and fury of the Atlantic can be photographed here. On a quiet day, walk along the seashore and look for tiny shells and creatures washed up on the beach. When a storm is raging, you will get your most dramatic shots. Back up and use a telephoto to keep your gear (and yourself) safe from the crashing waves. Another option for shooting at this location is a trail leaving from the northern parking lot. Climb between the dunes for a commanding view of the Atlantic. Keep in mind that photographs of waves taken from above lose a lot of their sense of scale. If you position your camera at or below the level of the wave crests, you will make them look even more powerful. Another way to put waves or dunes in perspective is to include a known object in your composition, such as the lifeguard chairs, surfers, or seals.

Directions: From US 6 in Truro, turn east onto Head of the Meadow Beach Road and follow to the end.

Days' Cottages (72)

This orderly row of 23 cottages is one of the Cape's most photographed sights. The buildings are identical, and the perfect row of them makes an interesting pattern. You can use a

wide-angle lens to accentuate the one in front of you and let the others fade into the distance, or use a telephoto lens to compress the perspective, which makes it look like the cottages are stacked on top of each other. At sunset, the cottages will be lit with warm orange light from the low-angled sun. Speaking of sunset, don't forget to turn around. The beach near the cottages is the perfect place to enjoy a panoramic view of Provincetown across the bay. In summer, the sun sinks in a fiery ball behind the town, silhouetting the church steeples and the tall spire of the Pilgrim Monument.

Directions: The cottages are located midway between Truro and Provincetown on Shore Road (MA 6A). From the US 6/MA 6A split in Truro, take the left-hand road (MA 6A or Shore Road), and drive north for 2.5 miles; the cottages are on your left.

Provincelands dunes (73)

If you really want to get lost on the Cape, this is the place for you. Miles of trails lead up, down, and around 60-foot-tall sand dunes ringed with beach grasses and wildflowers. There are several different trailheads where you can access this portion of the Cape Cod National Seashore wilderness. I recommend starting at the Snail Road trailhead. The trail begins in a thick forest, but quickly climbs a very steep, sandy hill to the top of the first dune. From here you can see the undulating hills of sand spread out before you. If you keep going straight (more or less) you will eventually come to the beach.

This is probably the toughest hiking on Cape Cod, especially in the heat of summer—hills, sand, and no shade. Be sure to bring plenty of water and food if you are planning a longer excursion (which you should be, because this is a remarkable place). The best light and weather for this area is a clear sky in the

Days' Cottages

morning or evening, when the sun will cast long shadows from the dune crests. An overcast sky gives the dunes a shapeless, less dramatic appearance. If you have the opportunity, visit immediately after a snowstorm—the interplay of sand and snow under a bluebird sky is one of the Cape's most impressive natural spectacles.

Directions: Driving north on US 6, watch for the large green sign indicating the Snail Road turnoff to the left. Directly opposite this turn (on the right side of the road as you're heading north) is a small dirt lot for two or three cars in front of a gate. If the lot is full you can park in the sand along the roadside.

Beech Forest Trail (74)

This 1-mile loop trail is an oasis of calm, particularly on a crisp fall day when the leaves are changing colors. Throughout the summer, the ponds are full of white water lilies, frogs, and dragonflies. My favorite spot is a short wooden boardwalk just past the restrooms that takes you, quite literally, into the middle of the water lilies. Composing shots of the flowers or symmetrical rings of green lily pads is a snap. There are lots of other subjects waiting in the

Sanderlings, Provincelands dunes

forest for you, so make sure you explore the entire trail. The best season to visit is fall, when the mosquitoes are dead and the trees are wearing their colorful autumn finery.

Directions: From US 6 in Provincetown, turn north at the traffic light onto Race Point Road. Drive for 0.5 mile and park at the large lot on the left.

Race Point Lighthouse (75)

This photogenic lighthouse requires some physical exertion—it's a 3-mile round-trip walk on a sandy trail. The track begins amid a stand of stunted pitch pines and cranberry vines. Emerging from the pines, you will be treated to a panoramic view of Hatches Harbor (to the left), a salt marsh (to the right), and the lighthouse (straight ahead). Continue along the causeway over a bridge and then cross the tidal creek (you may have to follow it upstream a bit to find a place to cross), then angle back to the lighthouse. There are no fences or power lines here to interfere with your shot, so experiment with your angle, lens, and distance from the lighthouse to find the best composition. Early morning and late evening will bring the best light, and a sunny day with puffy cumulus clouds adds the perfect backdrop. On a cloudy

day, stick to macro areas like the Beech Forest Trail or a cultural area like Commercial Street or MacMillan Wharf. Note that you can also get to the lighthouse via a 4-mile round-trip walk along the beach from Race Point Beach.

Directions: From US 6 in Provincetown, turn north at the traffic light onto Race Point Road. Drive past the visitor center and then turn left onto Province Lands Road. Pass the first parking lot on your right and continue until you see a second one. This is the trailhead to Hatches Harbor and the lighthouse.

MacMillan Wharf (76)

Provincetown's active fishing fleet is based at MacMillan Wharf. This large pier is also the home of whale-watching tours, the ferry to Boston, charter fishing boats, and the Whydah Museum pirate ship exhibit. There is plenty to keep you happily clicking away here, from detail shots of the fishing nets, buoys, and boats to herring gulls waiting for a free fish lunch. Since the pier is angled roughly from northwest to southeast, sunrise is particularly good here, and sunset is excellent as well. If you walk out far enough you'll be rewarded with a fine view of the city from the water. The best time to visit MacMillan Wharf is the Blessing of the

Fleet, a celebration of Provincetown's fishing heritage. It takes place at the end of June, on the last day of the Portuguese Festival.

Directions: From US 6, you will see multiple exits for downtown Provincetown. If you're coming for a few hours or the day, I recommend taking Conwell Street to Bradford Street, then turning left and parking at the large pay parking lot. Parking is only $2 per hour. Walk towards the water and you can't miss the pier.

Commercial Street Provincetown (77)

Provincetown, better known as "P-Town," is the epicenter of gay and lesbian culture in New England. Commercial Street is P-Town's heart and soul. The street runs parallel to the ocean for 3 miles, but most of the shops are concentrated around MacMillan Wharf (look for the cross-street named Ryder Street). The shops, bars, galleries, and dance clubs attract a kaleidoscope of people from all walks of life. If you want to capture some unique street scenes, just wander Commercial Street during one of Provincetown's festivals such as the Portuguese Festival (late June), Fourth of July weekend, the Gay Pride Carnival (mid-August), or the Holly Folly (early December).

Directions: Same as MacMillan Wharf.

Long Point (78)

This is another Provincetown natural site requiring some stamina, but the rewards are well worth the effort. Along the way to the end of this curving peninsula, you'll encounter two lighthouses and see views of Provincetown. Wood End and Long Point lighthouses are a 3-mile and 6-mile round trip from the parking area, respectively. The hike to either begins with a 1-mile rock hop across a long, arrow-straight breakwater. Consult a tide table before

MacMillan Wharf

Long Point Lighthouse

you begin this hike, because at high tide portions of the breakwater are submerged and the tidal current is swift. Getting your legs wet can be refreshing in summer, but dangerous in winter and spring (use extreme caution if the rocks are wet or icy). For added peace of mind, pack your camera gear in a waterproof roll-top dry bag that kayakers use and put that inside your backpack. That way, a misstep doesn't ruin your entire trip. However, don't let the caveats deter you; this is one of the most scenic walks on the Cape.

As you walk down the breakwater, don't forget to look over your shoulder—there are panoramic views of the Provincetown skyline from all along the breakwater. When you reach the sand, it's a short half-mile walk to Wood End Lighthouse, clearly visible to your right. The lighthouse is small and squat (only 39 feet high), but the pristine natural surroundings make it easy to take home a great photo. If you're feeling more adventurous, take a left at the breakwater instead of a right and hike 1.5 miles farther to the end of the sand spit to Wood End's twin brother, Long Point Lighthouse.

Since the spit of land is quite narrow, you have the option of walking on the exposed Cape Cod Bay side or the more protected Provincetown Harbor side. Both sides are equally beautiful. The bay side has bigger waves and lots of passing boats; the harbor side has tidal inlets (which may require a waist-deep wade to cross) and views of Provincetown. Plan your outing so you can watch the sunset from the end of your hike along the breakwater and you'll find some beautiful landscape light.

Directions: Follow US 6 to the end, turn left at the final T. Take this road (Province Lands Road) until you reach a small rotary. There are roughly 15 to 20 free parking spots along the road, and a few more metered spots at the western end of Commercial Street.

Recommendations: Truro and Provincetown are among the Cape's most popular tourist destinations, and for good reason. There are many "don't miss" sites here, so plan your trip carefully and be sure to budget extra time. If you want to put together an extremely full day, follow this jam-packed itinerary, or better yet, spend a week (or more) here. Wake up with the sun at Head of the Meadow Beach—it's the perfect spot to watch the waves and photograph hopping seals. After sunrise, head north to the Provincelands and wander the dunes before the sun gets too hot. If you're a lighthouse buff, visit Highland Lighthouse and hike out to either Wood End or Race Point. Then, head into Provincetown and explore the streets, shops, restaurants, and harbor. Be warned—you can easily lose yourself for an entire day exploring the dunes of the Provincelands or the town of Provincetown. Late afternoon is a great time to check out the line of symmetrical cottages at Days' Cottages, and sunset is the best time to shoot dinghies and other watercraft at Pamet Harbor. Lastly, don't forget to go on a whale-watch trip. If the whales are feeling

friendly, you will be able to take frame-filling shots of Cape Cod's most famous and graceful creatures with only a moderate telephoto lens. Whatever sites you choose to visit in this area, be sure to pack extra film or memory cards—this is a very scenic area.

Pro Tips: All of your lenses will be useful—wide angles to take in dune landscapes, telephotos for breaching whales, and everything in between. When the sky is clear and puffy clouds are scudding across the sky, it's hard to go wrong. When faced with the hazy, whitish skies of a humid August day, though, you'll need to get creative, which is never a bad thing. Put away the wide-angle and try a landscape with a telephoto lens. Look for compositions that don't include the sky, or focus on macro subjects like sand ripples, beach critters, dune flowers, or street scenes. Also, if the haze is thin, be ready for a stunner of a sunset—as the sun sinks into the haze layer it will become a round ball of orange light. It makes a great accent to a photo of the Provincetown skyline from North Truro (at the Days' Cottages site).

Cautions: Truro and Provincetown cautions are much the same as the rest of the Cape—beware the traffic, parking, sand flies, and ticks. My best tip for this area to maximize your enjoyment is to visit in the off-season. In particular, the "shoulder" months of May in the spring and October in the fall will mean less time spent sitting in traffic and no beach parking fees. Late September through October is my absolute favorite time to photograph this area—the skies are generally dry and clear, the beach grasses and deciduous trees are changing colors, and the smell of wood-burning stoves is in the air.

Diversions: Provincetown is the closest you can get to Massachusetts's most photogenic marine mammals: the humpback, minke, and other whales that frolic and feed just offshore. A number of tour companies, such as Dolphin Fleet (www.whalewatch.com) and Portuguese Princess (www.princesswhalewatch.com), run whale-watch tours from April to October, and should not be missed. On a good day it's possible to encounter 20 to 30 whales in just a few hours. The sight of these massive creatures feeding, diving, and breaching may leave you speechless. Don't forget to push the shutter. For more tips on photographing these gentle giants, check the "How I Photograph the Cape and Islands" section at the beginning of this book. Other Provincetown diversions include the Whydah pirate ship museum on MacMillan Wharf and the Pilgrim Monument, which you can climb for an aerial view of the town. After sunset, take in some of P-town's famous nighttime entertainment like a cabaret show.

Pamet Harbor

IX. Martha's Vineyard

SEASONAL RATINGS: SPRING ★ ★ ★ ★ SUMMER ★ ★ ★ ★ FALL ★ ★ ★ WINTER ★ ★

General Description: Martha's Vineyard is one of the most popular travel destinations on the East Coast. Celebrities and politicians rub shoulders with fishermen and sun-baked tourists. Beaches, lighthouses, historic homes, and harbors make this island worth the price of admission.

Directions: The island can be reached by air or by boat. Ferries depart Cape Cod from Woods Hole (Steamship Authority, www.steamshipauthority.com), Falmouth Harbor (Island Queen, www.islandqueen.com), and Hyannis (www.hy-linecruises.com). The Steamship Authority is the only ferry that can carry cars as well as passengers and bikes. Be sure to check the ferry websites for schedules (some do not run in winter) and where the ferries dock on the Vineyard (either Vineyard Haven or Oak Bluffs). There are several car rental companies and a multitude of bike rental shops if you feel like arranging your own wheels. Generally speaking, if you are staying more than two days it's more economical (though advance reservations are required) to bring your car on the ferry. For shorter trips, it's cheaper to rent a car or bike.

Specifically: Martha's Vineyard is a microcosm of the Cape's finest photographic subjects—untamed beaches, quiet forests and meadows, lighthouses, and traditional architecture. But there are also unique surprises—a Japanese garden, the colorful gingerbread houses of the Campmeeting Association, and the dramatic clay cliffs of Aquinnah.

Where: A 23-mile-long island off the Cape's southwestern corner

Noted For: Multihued clay cliffs, lighthouses, and gingerbread cottages

Best Time: Late May, July, and mid-October

Exertion: Minimal to moderate at some natural sites

Peak Times: Spring: late May; Summer: June to July; Fall: October; Winter: January

Facilities: At developed sites

Parking: In lots or street side in towns

Sleeps and Eats: Accommodations and restaurants are concentrated in the towns of Vineyard Haven, Oak Bluffs, and Edgartown

Sites Included: Vineyard Haven Harbor, Tashmoo Overlook, Cedar Tree Neck Wildlife Sanctuary, Menemsha Hills Reservation, Menemsha Harbor, Gay Head Lighthouse, clay cliffs of Aquinnah, Alley's General Store, Long Point Wildlife Refuge, Mytoi Japanese Garden, Wasque Reservation, Edgartown town and harbor, Edgartown Lighthouse, Felix Neck Wildlife Sanctuary, Joseph Sylvia State Beach Park, Gingerbread houses, East Chop Lighthouse

Vineyard Haven Harbor (79)

In summer this harbor is chock-full of moored sailboats and yachts. What most people don't appreciate, though, is how different this harbor looks at sunrise. When the morning sun peeks up behind the sailboat masts, the entire harbor is lit up with orange and red hues. The best mornings are windless ones, when you can take longer exposures and still get sharp shots. If you are having a hard time making a clean com-

position of the mass of boats (an understandable dilemma), try using a telephoto lens in the 200–300mm range to isolate reflections or single boats. To get a better vantage point on the sailboats, walk from the Steamship wharf north along a small sand beach to a wooden pier, or continue farther to a stone breakwater. Be careful on the rocks, since they can be slippery when wet from sea spray or rain.

Directions: A short walk north of the Steamship Authority wharf in Vineyard Haven takes you to the harbor vantage points.

Tashmoo Overlook (80)

This pastoral area is reminiscent of English countryside. Open fields lead downhill to Drew's Cove on Tashmoo Lake. In spring and summer the water glows green from reflecting the thick vegetation ringing the edges. This is the way much of the Cape and Islands looked after European settlers transformed the landscape into pasture and farmland. Walking down through the field you will come across the historic water pump house. The building itself is photogenic, with a tall brick chimney and ivy crawling up the walls. However, a chainlink fence around the entire structure makes it difficult to find a clean composition. Your best bet is hiking uphill a bit so that you can look down at the structure. A variety of birds can be found enjoying the lake waters, including herons, swans, and swallows.

Directions: Tashmoo Overlook is located just a half mile from downtown Vineyard Haven. Take State Road southwest out of the town of Vineyard Haven and park at the pull-off overlooking the fields.

Cedar Tree Neck Wildlife Sanctuary (81)

Tucked away down a long dirt road is this intimate nature preserve encompassing both forest and beach ecosystems. An interpretive trail

Vineyard Haven Harbor

takes you past a quiet pond. The view is somewhat overgrown, but with a telephoto lens you can get some clean photos of the trees reflected in the water on the other side. Late afternoon will paint them with warm light. The trail will continue past a beech forest to a Vineyard Sound beach. In late fall and winter you can shoot sunset here. However, be aware that the parking lot is only open from 8:30 AM to 5:30 PM, and the gate is locked at night, so don't dally.

Directions: From Vineyard Haven, drive southwest on State Road, then turn right onto Indian Hill Road and follow it for 1.3 miles. A sign will guide you to the next turn, a right onto Obed Daggett Road. The sanctuary is at the end of this single-lane dirt road. Drive slowly.

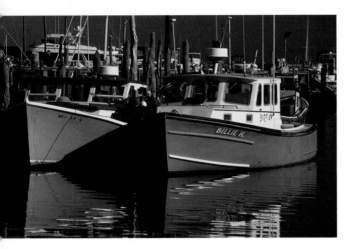
Menemsha Harbor

Menemsha Hills Reservation (82)

Lace up the hiking boots. This is one of the few places on Martha's Vineyard where you can walk for hours and not see another soul. In addition to peace and solitude, these forest trails have some of the best views on the island. The first vantage point, roughly a 20-minute walk from the parking lot, is Prospect Hill. At 308 feet in elevation, this is a veritable mountain for the Cape and Islands. The view from here takes in the village of Menemsha, Gay Head Light, and the Elizabeth Islands.

Another half-hour of walking through the scrub oak forest takes you to a second overlook called the Great Sand Bank lookout. This vantage point is even better for photography since it affords a less obstructed view of the ocean from the 150-foot bluff top. A further 10 minutes of walking takes you through a flower-bedecked valley to the rocky shoreline. Although this might seem like an inviting sunset location, keep in mind that it's a 30 to 40 minute hike back to the parking lot, which you don't want to do in the pitch darkness. The woods are particularly photogenic when the leaves are changing colors in the fall, and also after a winter snowfall.

Directions: From Vineyard Haven, drive southwest on State Road, then turn right at the junction with North Road. Follow North Road 4.5 miles southwest, then turn onto Trustees Lane. The parking lot for the preserve is just to the right.

Menemsha Harbor (83)

Menemsha Harbor is my favorite photography site on Martha's Vineyard. To me, Menemsha feels more "real" than the refined and produced perfection of other Vineyard villages. Many of the tiny fishing shacks are built on stilts right over the waters of the harbor. Fishing boats are mixed in among the yachts and sailboats, providing a diversity of nautical subjects. The catch of the day is unloaded and sold at small seafood shops right on Dutcher Dock. Access is easy; you can walk all around the harbor for a variety of shooting angles.

Menemsha is popular in summer and parking is limited, so I prefer to visit early in the morning when most of the vacationers are still snoozing. The chaotic mass of boats can be difficult to distill into a workable shot. I prefer to use a telephoto lens to isolate bits of the composition that are appealing, like some buoys or a coil of line on the dock. The beach at the end of the parking lot is a sandy west-facing beach with easy access, making it a fine sunset spot. One last tip—tucked amid the dunes north of the Dutcher Dock parking area is a beautiful sculpture, the "Swordfish Harpooner."

Directions: From Vineyard Haven, drive southwest on State Road, then turn right at the junction with North Road. Follow North Road straight into Menemsha Harbor. The legal parking times vary from a half-hour (near the shops) to five hours (the beach parking lot at the end of Dutcher Dock). Try to get one of the five-hour spots, since you'll want to spend some time here. Incidentally, it's a great place for lunch.

Gay Head Lighthouse (84)

This famous lighthouse perches in a dramatic location at the top of the clay cliffs. The classic view is easily reached by walking past the small collection of shops and restaurants to a fenced overlook area. The lighthouse is still functional, so try to time your shot to coincide with the light shining at you—it will add a nice highlight to your photograph. However, bear in mind this simple caveat: always remove your filters when shooting into a point light source like a lighthouse beam. A filter, especially an inexpensive UV filter, may cause unnatural duplicate reflections of the light source (known as ghosts) to show up in your photo. If you're shooting digital you can confirm this by checking the final photo on your LCD monitor.

This is also an ideal spot to try out a panoramic shot. Using a normal or short telephoto lens, set your camera on manual exposure and determine a proper exposure for the entire scene. Then, level your tripod and pan across the scene, shooting with an overlap of about 30 percent between photos. You can assemble the images later using a variety of different software packages. Digital shooters have an advantage here because you can check the results of your series quickly on the LCD.

Directions: From Beetlebung Corner in Chilmark (intersection of Middle, South, and Menemsha Cross Roads), drive west on State/South Road until you arrive at the end of the island.

Clay cliffs of Aquinnah (85)

Are we still in New England? This may be your first thought when you see these 150-foot-tall, multicolored cliffs plunging into the sea just

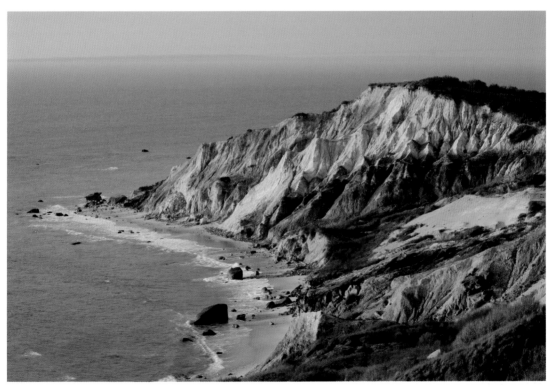

Clay cliffs of Aquinnah

under the Gay Head lighthouse. The striated clay cliffs were formed, like many of the landmarks on the Cape and Islands, by glacial action over 100 million years ago. In the distance you can easily make out the low humps of the Elizabeth Island chain stretching out from Woods Hole. Since the cliffs are west facing, the best time to visit is at sunset. This is not a secret, and during the summer you will find the small overlook area (just beyond the tourist shops at the parking lot) extremely crowded. However, the crowds are there for good reason—the view is impressive, allowing you to photograph either the cliffs, the lighthouse, or, with a wide angle lens, both.

If you want a up-close and personal view of the cliffs, you will have to do some work. Head down Moshup Trail Road; you can't miss the beach parking area. Beach access is free but parking will set you back $15 for a day. You can then hike up the beach to the base of the cliffs. Keep in mind that the cliffs are owned by the local Wampanoag Indians, so show proper respect by not climbing them or splashing around in the pools formed at their base.

Directions: Same as Gay Head Lighthouse (above).

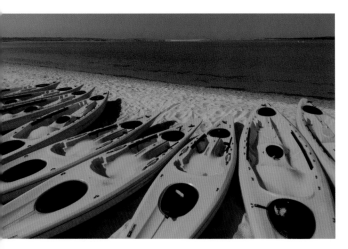

Long Point Wildlife Refuge

Alley's General Store (86)

"Dealers in Almost Everything" reads the sign hanging in front of this classic New England general store. Living up to its name, it's a place where you can find almost anything, including some memorable photos. The store is the oldest retail establishment on the Vineyard, dating to 1858. The front of the building faces eastward; come in the morning for light on the facade. It's also productive to browse the postcard rack so you can see the successful images other photographers have made on the island.

Directions: On State Road just south of the intersection with the Edgartown–West Tisbury Road.

Long Point Wildlife Refuge (87)

This 633-acre area owned by The Trustees of Reservations is a goldmine for outdoor photographers. Wildflower meadows, well-maintained trails through oak forest, a wildlife blind on Long Cove Pond, and a broad, sandy south-facing beach make this an ideal spot to devote an entire morning or afternoon. Whether you're interested in shots of surfers riding the crashing waves or osprey diving for fish, Long Point will not disappoint you. Pick up a map when you arrive at the visitor center, since the property is sprawling. From the off-season parking lot and visitor center, it's about a 10-minute walk southward to the beach between the meadows.

Taking the trails northward from the lot will lead you past engaging views of Long Cove Pond to a wildlife blind. The refuge does not admit dogs, so you have a better chance of seeing wildlife here than at other spots frequented by canines. Throughout the year, white-tailed deer can be seen, particularly at dawn and dusk. The bird life is seasonal. In the winter, snowy owls and bald eagles are occasional visitors. In the spring, endangered piping plovers lay their eggs and raise their young here. In the

fall, Long Point is a critical stopover area for countless species of migrating birds. Come early in the morning or late in the afternoon for your best chance to see photogenic critters.

Directions: There are two access points, depending on the season you visit. In summer (mid-June through mid-September): from Edgartown–West Tisbury Road, drive west 0.3 mile past the airport main entrance, then turn left onto Waldron's Bottom Road. Signs will guide you the rest of the way (2.5 miles) to the summer parking lot (120 cars). If you visit in the off-season (mid-September through mid-June), follow these directions. Drive 1.1 miles west of the airport entrance, then turn left onto Deep Bottom Road. Follow the signs for 2.8 miles down single-track dirt roads to the smaller (30 cars) parking area. The fee for parking in summer is $10, and the adult admission fee is $3 per person. In the off-season, access is free.

Mytoi Japanese Garden (88)

After fighting the tourist hordes in Oak Bluffs or Edgartown, you'll find this small garden, on the petite island of Chappaquiddick, off the eastern coast of Martha's Vineyard, to be an oasis of tranquility. A series of groomed paths and wooden bridges lead walkers through the exquisitely manicured grounds. A variety of flowering plants makes this a superb site for macro photography. Be sure to walk around the network of trails before you start shooting. As you walk, compile a list of possible shots in your head, and then return to the most compelling spots.

When taking close-up photos of flowers, pay extra attention to the background. Make sure that there are no offending sticks or bright highlights poking in; these will be very distracting in the final photo. Usually a move of only a few inches to either side will result in a dramatic change in your background.

Wasque Reservation

The Mytoi parking area is the departure point for The Trustees of Reservations guided fishing and canoeing trips to Cape Poge, a remote natural area on Chappaquiddick's northeastern shore. The only way to access Cape Poge is through a tour or with a 4WD vehicle and beach-driving permit.

Directions: Take the tiny ferry from downtown Edgartown across the harbor. Continue straight down Chappaquiddick Road until you arrive at a 90-degree bend to the right. Follow the dirt Dike Bridge Road straight for about a half mile; Mytoi will be on your left.

Wasque Reservation (89)

Whenever I visit Wasque, at Chappaquiddick Island's southwestern corner, I feel like I'm at

Edgartown

lar light on the land makes for dramatic landscape shooting. If you feel like swimming, save your energy for a safer spot—the currents here are notoriously strong.

Directions: From the ferry, follow Chappaquiddick Road through the 90-degree southward bend, then through another 90-degree eastward bend, and continue to follow it to the end. The last mile or so is a rutted dirt road.

Edgartown town and harbor (90)

Edgartown is the Vineyard's crown jewel of urban sites, a gem of cedar-shingled perfection. It seems like every hydrangea blossom is just the right shade of blue and every old sea captain's house has a freshly painted white picket fence. The narrow streets are perfect for wandering and getting lost (if you can). Colonial history peeks out from around every corner. In particular, be sure to visit the Old Whaling Church with its massive Greek columns. After exploring the back streets, spend some time at the waterfront. Colorful fishing boats and sailboats can be found all along the piers. The best time to visit is midweek or during shoulder seasons of May and October, when you'll have the place (mostly) to yourself.

Directions: From Vineyard Haven, take the Edgartown–Vineyard Haven Road southeast to Edgartown.

Edgartown Lighthouse (91)

This is one of the best lighthouses to photograph on the Cape and Islands since there are no distracting fences or power lines to interfere with the background and the grounds are open to the public at the golden hours of sunrise and sunset. The sandy shore, beach grass, and lighthouse will be all yours if you visit at sunrise. In summer, the sun rises behind the lighthouse if you are standing on the wharf just behind the Chappaquiddick ferry. Shoot from

the end of the earth—an especially odd feeling considering how many people visit Martha's Vineyard in the summer. Over 200 acres have been preserved here for hiking, fishing, sunbathing, and, of course, photography. Your first view is that of rolling meadows, which have been preserved by The Trustees of Reservations through a program of controlled burning. Without the burns, fast-colonizing pitch pine and scrub oak would quickly take over. Beyond the fields, a sandy beach, two boardwalks, and a trail overlooking a quiet pond await.

The pond, appropriately named Swan Pond, is one of the Vineyard's top birding spots, and numerous ducks, cormorants, and swans can be seen preening and feeding on the beach or in the pond. The fields also attract a host of smaller birds including flocks of tree swallows. Take your time and explore this area slowly. At sunrise and sunset, the warm, angu-

the wharf and then walk (15 minutes) up to the beach surrounding the lighthouse. After you have bagged the standard shots, try some experimentation. For example, put some beach grass in the foreground and use a telephoto lens with the aperture opened all the way. This will render the green beach grass as a soft, abstract framing element.

Directions: From the Chappaquiddick ferry in downtown Edgartown, walk northwards on North Water Street until it ends. Look right and you'll see the lighthouse.

Felix Neck Wildlife Sanctuary (92)

This large natural area, tended by the Mass Audubon Society, has a huge array of ecosystems and subjects to keep any nature-shooter happy. From the turtle pond to the butterfly garden and salt marsh views, you won't be dis-appointed at any time of year. Four and a half miles of broad, well-tended trails wind through the property. Be sure to pick up a map at the entrance so you don't get lost. My favorite spots include the turtle pond, specifically the view from the wooden bridge, watching waterfowl from the bird blind, and the views of Sengekontacket Pond.

Directions: Watch for the Felix Neck Road (dirt) turnoff from the Edgartown–Vineyard Haven Road, 4.2 miles east of Vineyard Haven. Drive down the dirt road (0.5 mile) to the parking lot. Admission is free for Mass Audubon members and $4 for nonmembers. The fee is the reason why these trails are so well-kept. It's cheaper than an ice cream in Edgartown, so just pay the fee and enjoy the trails.

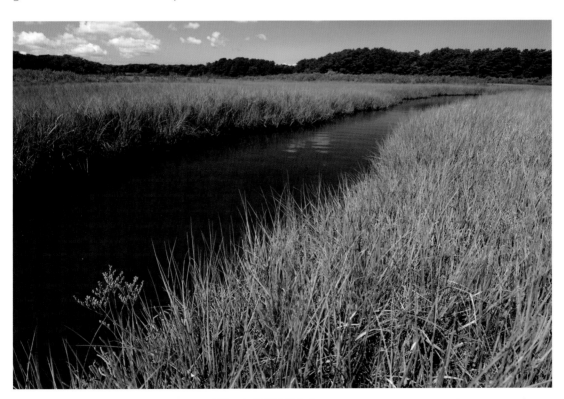

Felix Neck Wildlife Sanctuary

Joseph Sylvia State Beach Park (93)

This 2-mile-long narrow strip of sand with a road through the middle is a popular sunbathing spot in summer. On the west side of the road is Sengekontacket Pond, and on the east side is Vineyard Sound. This park is a fun place where you can photograph kids (and adults) fishing, sailing, and jumping into the cold Vineyard Sound waters from two small bridges. It's also a prime spot for photographing sunrise or sunset. However, if you're looking for big waves this is not the place—it is protected from most of the Atlantic's fury. Head to the south side of the island (Long Point or South Beach) for large rollers and crashing waves.

Directions: You can't miss it—the park is right off Beach Road (well sign-posted) in between Oak Bluffs and Edgartown. Parking is along the roadside.

Gingerbread houses (94)

These small, brightly colored Victorian homes are one of the highlights of Martha's Vineyard. It almost feels like you've been transported to another country, or another time. The over 300 cottages are all uniquely painted, most of them in vivid colors. The heart of the cottage area is the Trinity Park Tabernacle, a giant, circular, iron structure built in 1879 as a shelter for meetings and sermons. My advice is to take a stroll around the area and make mental notes of which houses (and what about them) catch your eye. Return to those and spend some time exploring different angles.

If the sky is a boring whitish-grey overcast, put on a normal lens or moderate telephoto in the 50–100mm range, and compose your photos without any sky. Summer is the best season to photograph here since the flower-boxes will be full of beautiful blooms.

Directions: From Vineyard Haven, follow Beach Road to Oak Bluffs. The road will become Eastville Avenue. At the T, turn right onto New York Avenue and follow it to the harbor. If you have a car, try to find parking here. The majority of the cottages are bounded by Dukes County Avenue to the west and Circuit Avenue to the east. No cars, bikes, or mopeds are permitted on the pedestrian pathways around the cottages.

Gingerbread houses, Oak Bluff

East Chop Lighthouse (95)

This petite white lighthouse is sited in attractive mowed grounds with a view of the ocean behind. The property ends at a 50-foot bluff overlooking the ocean (don't climb on the bluff, it's eroding badly enough without your help). While early morning or late evening will give you the best light, the lighthouse can be photographed almost any time of day. A white picket fence and "Telegraph Hill" sign mark the entrance, which can be used as foreground elements.

Directions: The lighthouse is at the north end of Oak Bluffs. From Oak Bluffs Harbor, drive north on East Chop Drive along the west side of the harbor until you reach the lighthouse, roughly 0.7 mile down the road.

Recommendations: Martha's Vineyard is not only captivatingly scenic, but also deceptively large. It can take over 30 minutes just to drive from the western corner (Aquinnah) back to Vineyard Haven, and that's in the off-season. When the roads are jammed with cars, bikes, and mopeds in the summer, travel is considerably slower. For that reason, if you have only a day or two on the Vineyard, I recommend choosing to shoot along the western ("up-island") side or the eastern ("down-island") side, but not both. If you choose west, you can photograph effervescent sunsets, the clay cliffs of Aquinnah, and the charming fishing village of Menemsha. If you choose east, you can explore the wildness of Wasque on Chappaquiddick, the tidy perfection of Edgartown, and the brightly painted Victorians in Oak Bluffs. Either way, you won't be disappointed.

Pro Tips: Martha's Vineyard is an extremely popular destination, so a lot of photographs have been made here. It is a worthwhile activity to review the postcards in the display racks to get a preview of the island's attractions. Not only is it important to find out what locations look like, but also it may tell you what shot has been "done to death." Then, when you are faced with a familiar subject, try to come up with your own unique twist. There is no universal formula for creativity, but one tip is to slow down and take your time. I recommend leaving the camera in the bag and walking around the subject, considering it from every angle—high, low, from the front, back, and side. Keep an eye not just on how the subject changes with the lighting, but also how the background changes. I can virtually guarantee that you will find better compositions than the first one you came up with.

Cautions: It costs over $100 to get your car on and off the island, and that's assuming you can even get a reservation. Even the cheapest car rental will set you back roughly $70 per day. You may be tempted to rent a moped. However, I would strongly advise against it. I have personally witnessed two moped accidents; one driver smashed headlong into an ice cream parlor glass window. Not a fun way to end your vacation. Two other transportation options are the frequent, inexpensive, and convenient bus system and the many bike rental shops. The extensive network of bike paths means that you rarely have to share the roadway with cars. At the risk of sounding like your mother, please wear a helmet.

Diversions: There is no shortage of diversions on the island. A number of tour companies operate informative bus tours, harbor cruises, fishing trips, and kayaking excursions. One notable historic diversion in Oak Bluffs (intersection of Circuit and Oak Bluffs Avenues) is the Flying Horses Carousel, the oldest platform carousel in the United States. There is also the legendary Black Dog Restaurant and Bakery. You haven't been to the Vineyard if you don't come back with a Black Dog t-shirt.

X. Nantucket Island

SEASONAL RATINGS: SPRING ★ ★ ★ **SUMMER** ★ ★ ★ **FALL** ★ ★ ★ ★ **WINTER** ★ ★ ★

General Description: Nantucket Island is an escape from reality. Whether you are looking for photos of New England's historic whaling captains' mansions or towering North Atlantic waves pounding the beach, Nantucket will exceed your expectations (and your pocketbook).

Directions: A number of small airlines, such as Nantucket Airlines and Island Air, get you to Nantucket in a short 15 minutes from Hyannis airport. Alternatively, there are slow (three-hour) and fast (one-hour) ferries that depart from Hyannis and Harwichport. Although you can bring a car on the slow ferry, it is much cheaper to rent a car if you are staying for a day or a weekend.

Specifically: Also known as the "Grey Lady," Nantucket is the epitome of Old-World New England elegance. The multimillion-dollar houses, some dating back to the 1700s, were once the homes of whaling captains and cod fishermen. Nearly half of the island has been preserved from development by an effective land bank program, resulting in some unique

Where: 30 miles out to sea in the North Atlantic, south of the Mid-Cape

Noted For: Historic homes of whaling captains, an excellent museum, lonely moorland, dramatic sea cliffs, and lighthouses

Best Time: Early June and late October

Exertion: Minimal

Peak Times: Spring: May; Summer: June; Fall: mid- to late October; Winter: January

Facilities: At developed sites

Parking: In lots

Sleeps and Eats: Many in Nantucket Town

Sites Included: Nantucket Town, Brant Point Light, UMass Field Station, Middle Moors, Pocomo Head, Squam Swamp, Siasconset and Sankaty Light, Surfside Beach, Sanford Farm, Ram Pasture, and The Woods, Madaket Beach

nature photography destinations: open moorland, a spooky swamp, and miles of sandy beaches. Note that I have included only sites that are easily reached by 2WD vehicle, bicycle, or foot.

Nantucket Town (96)

"Town," as the locals call Nantucket Town, is the hub of activity for the island. It is also an architectural photographer's dream, with more houses built before 1850 than any other city in the United States. In fact, the entire town is a National Historic Landmark. My advice for tackling this town, which can be either sleepy or bustling, depending on the season you are visiting, is to start at the wharf and work your way inland, letting your eye guide you from street to street. It's nearly impossible to get lost, but give it a shot and you may just find a unique image.

Pocomo Head

Some of the "don't miss" sights include the cobblestone-paved Main Street, the nine properties owned by the Nantucket Historical Association, and the Greek Revival library. The cramped streets make backing up almost impossible, so if you want to "get it all in" you'll need a wide-angle lens. Note that as you tilt that lens up, you will see all of your straight lines start tilting inward. Your solutions to this problem include using a tilt/shift lens, backing up and using a moderate telephoto, or correcting the perspective in Photoshop later (for details, see "Pro Tips"). Just watch out for cars if you back up.

Directions: You can't miss it. When arriving by ferry, you will step off the pier into the heart of Nantucket Town. If you arrive by air, the town is 10 minutes to the west by car down Milestone Road.

Brant Point Light (97)

This is one of Nantucket's icons, and "The Shot" is fairly obvious. A long wooden boardwalk leads to the small lighthouse, almost as if it was put there for wide-angle enthusiasts who love leading foregrounds. That said, this particular photograph has become somewhat clichéd and it's worthwhile to look for some other vantage points by walking around the lighthouse. Unlike many of the Cape and Island lighthouses, this one is not (yet) fenced in or hemmed by power lines, so you can shoot it from almost any angle. From the traditional view, Nantucket Harbor is in your background. From the other sides, you can put the beach or town in your background.

Directions: From the center of Town, walk north on South Beach Street until you intersect Easton Avenue. Follow Easton Avenue eastward (toward the ocean) until you reach the lighthouse.

University of Massachusetts Field Station (98)

A variety of environments are all within easy reach at this natural area. From the parking area, hike around ponds and a beautiful grass-filled meadow to a small rise overlooking Nantucket Harbor. The meadow is mowed every winter by the University of Massachusetts staff, allowing it to grow back to a beautiful sea of grasses and wildflowers every summer. Ox-eye daisies and goldenrod are the most common flowers here, which attract numerous butterflies such as the pearl crescent.

Directions: Driving east on Polpis Road, the UMass Field Station is well-marked by a sign on your left about 0.2 mile past the Lifesaving Museum.

Brant Point Light

UMass Field Station

Middle Moors (99)

Technically speaking, these windswept open "moorlands" are really not moors at all, but sandplain grassland, coastal heathland, and scrub oak barrens. Botanical terminology aside, when the fog hangs low over the grassy hillsides, you'll feel like you're wandering the hills of Scotland. The best time to photograph the Middle Moors is mid-September to mid-October, when the bayberry and huckleberry leaves turn scarlet and yellow. On foggy days, use a polarizer to maximize the color of the leaves. A polarizer will eliminate reflections and give your image a boost in saturation.

On clear days, plan your photography for early or late in the day, when the low-angled light paints the landscape with warm light. The

Middle Moors are the largest expanse of undeveloped conservation land on Nantucket (3,220 acres), so finding the best spot can be a challenge. One of the best vantage points over the moors is Altar Rock, an easy 20-minute walk from the parking area on Altar Rock Road. The 111-foot "peak" isn't the highest on Nantucket but does afford views over the heath.

Directions: The Middle Moors dominate the middle of eastern Nantucket and numerous trailheads exist. The Altar Rock parking area is only 50 yards past the UMass Field Station, just off a dirt road (Altar Rock Road) on the right traveling eastward on Polpis Road. There are two parking areas within a hundred yards of Polpis, although 4WD vehicles are free to drive the dirt roads that crisscross the moors.

Pocomo Head (100)

This sandy spit extends into windswept Nantucket Harbor. This is a great spot for both sunrise and sunset shooting since you have commanding views looking both west and east. It is also an excellent place for beachcombing—all sorts of interesting shells can be found here, all of which make excellent macro subjects. If the wind is really howling, windsurfers and kitesurfers will be racing around the bay.

Directions: From Polpis Road heading away from Town, take a left onto Wauwinet Road, then another left onto Pocomo Road. Follow it until it ends at a sandy parking area for about 15 cars.

Squam Swamp (101)

This could be one of the biggest surprises on Nantucket Island. A 1-mile round-trip trail leads you through stands of gnarled red maples, fern-filled groves, and vernal pools. Each season brings new subjects to Squam Swamp. Starting in April, spring peeper frogs begin their loud chorus. Next, the cinnamon

and bracken fern fiddleheads will start to unfurl their tender shoots. They make excellent macro subjects—don't forget a tarp or towel to lie on when you are stretched out to get that close-up portrait. In summer, the full-grown ferns blanket the forest floor. In autumn, photograph the changing leaf colors, especially in the tupelos and maples. Winter is also a great time to visit—look upwards to photograph the web-like interlacing of the oak branches.

Directions: From Polpis Road, turn northwards onto Wauwinet and look for signs on the right side of the road for Squam Swamp. The parking lot is near the intersection with Pocomo Road.

Siasconset and Sankaty Light (102)

The tiny seaside village of Siasconset, commonly shortened to 'Sconset, may be the most picturesque town not only on the Cape and Islands, but also New England. In summer, roses and hydrangeas clamber all over the weathered cedar-shingle homes. The houses are packed together in a huddle overlooking the fierce Atlantic Ocean, which continues to tear away the land and return Nantucket to the sea.

Walk up and down Broad and Front Streets to find the best angles for photographing the houses, but please be discreet since these are privately owned homes. You probably wouldn't want someone sticking a lens in your window! Walk downhill to Codfish Park to see views of the tiny village from the beach.

About a mile north of the center of town, Sankaty Light warns mariners away from the deadly shoals just offshore. The red-and-white-striped lighthouse was built in 1850 and is still in operation. Photographing Sankaty is

Winter at Squam Swamp

a bit of a challenge thanks to the unphotogenic chainlink fence backdrop that keeps tourists from falling off the cliff. If the clouds and sky are cooperating, you can shoot straight up at the lighthouse and avoid the fence entirely, like I did for the cover of this book.

Directions: The fastest way here from Town is to take Milestone Road eastward until it ends at the center of 'Sconset. The lighthouse is at the end of Baxter Road, about a mile from the center of the village.

Surfside Beach (103)

Surfside Beach is a broad sandy beach facing the open Atlantic Ocean to the south. In addition to the beach, this area also boasts sand dunes as wide as a football field. If the wind is southerly, this is where the massive northbound Atlantic swells first meet land, and the results can be spectacular. Keep in mind that this also means that the sea spray will be flying, sometimes well inland, so keep your camera protected by covering it with a plastic bag or some other kind of housing. Salt spray is perhaps the most insidious destroyer of electronic equipment. If the light isn't spectacular, sometimes it is just better to watch the spectacle in-

Surfside Beach

stead of trying to capture it on film. If the waves are quiet, keep an eye out for detritus washed up on the beach for macro shots, shoot the lifeguard chairs, or the patches of silvery dusty miller plant growing at the dune's edge.

Directions: From Town, follow the bike path along Surfside Road straight south to the beach parking.

Sanford Farm, Ram Pasture, and The Woods (104)

You'll feel like Thoreau when you start off down the 3-mile (one-way) trail from the parking area at The Woods. The trail follows a bare ridgeline affording views south to Hummock Pond. You can photograph meadow grasses and flowers on the way to a barn (1.6 miles along the trail) and the beach (at the end of the trail at 3.3 miles one way). The deer ticks are so prevalent here that scientists use this location for research, so wear light-colored clothing and check yourself thoroughly for the despicable varmints when you get back to the trailhead.

Directions: From Town, head west on Madaket Road only about a mile and a half; the parking area will be on your left just before the junction with Cliff Road.

Madaket Beach (105)

Madaket is one of the best sunset-over-open-ocean locations on the island, since most of the other Atlantic beaches have a more southerly exposure and Madaket faces (mainly) westward. I don't mean to belabor the point, but be careful when the big waves are rolling in.

Directions: From Town, follow Madaket Road westward until it ends. Parking is along the west (ocean) side of Ames Avenue, and is extremely limited.

Recommendations: My recommendations depend on what kind of transportation you

have available. If you come over for just the day and have no transportation, you can still fill your time (and then some) walking the cobbled streets of the old town and photographing the boats at the wharf, historic buildings, Whaling Museum, and Brant Point Lighthouse. If you bring your bicycle and want to see some of Nantucket's natural charms, either head west to the Sanford Farm and Ram Pasture area, or for a taste of the wild sea go all the way to Madaket. If you fancy photographing a Scottish-looking landscape, pedal eastward to take in the Middle Moors and then stop off to wander among some of the most expensive seaside homes in the country in 'Sconset. If you have a car you can (with some effort) visit all of these sites in an action-packed weekend.

Pro Tips: Shooting architectural gems like whaling captains' houses can be a tough prospect when the streets are narrow and you can't back up. Inevitably, you wind up putting on the wide-angle lens and pointing it upward to take it all in, resulting in the "leaning tower of Pisa" look. Fortunately, there are several solutions. One is to use a camera or lens with the ability to tilt and shift the focal plane. This will allow you to render those straight lines straight even if you have to tilt upward. Another (easier and much cheaper) solution is to back up and use a telephoto lens. However, this might be impossible given the narrow streets in Nantucket Town and 'Sconset. A third option is to use the computer. In Adobe Photoshop, use the Transform tool "Distort" by pulling outward on the top corners of the image until your vertical lines are straight up and down. This works best on images that need only a little help.

Cautions: If the winds are really howling, the ferry occasionally can be shut down, so if your schedule is tight make sure to check the weather before making the crossing. One of the biggest cautions regarding Nantucket has noth-

'Sconset

ing to do with the weather. Nantucket is small and extremely popular with the jet set, so reservations for a summer weekend are mandatory and many hotels require you to book a full weekend at once. If you can, time your visit for the shoulder season months of May or October, when you will spend less time wrangling with other tourists, find lower prices for accommodations, and just enjoy yourself more in general. A tip for finding a hotel is to use the Nantucket Chamber of Commerce (www .nantucketchamber.org). If you decide to go in summer, call the chamber ahead of time (508-228-1700); they can tell you what hotels still have availability plus the cost and contact information for each.

Diversions: Even if you're in Nantucket only for the day, don't miss the Nantucket Whaling Museum on Broad Street. Devoted to Nantucket's whaling past, this recently renovated museum is a cornucopia of whaling paraphernalia, including an entire sperm whale skeleton, old harpoons, portraits of whaling captains, and scrimshaw, all arranged in informative displays. You can also get a great view of the town from the rooftop observation deck.

XI. Favorites

Lighthouses
Edgartown
Brant Point
Nobska
Stage Harbor
Race Point
East Chop
Wood End
Highland
Chatham
Sankaty Head

Beaches
Nauset
The Knob
First Encounter
Head of the Meadow
Paines Creek
Coast Guard
Sesuit
Old Silver
Sandy Neck
South Cape

Flowers
Pink lady's slipper
Day lilies
Beach pea

East Chop Lighthouse

Butterfly weed
Swamp rose mallow
Greater blue flag iris
Beach rose
Hydrangeas
Trailing arbutus
Sea lavender

Nonphotography Places
Nantucket Whaling Museum
The Ice Cream Smuggler, Brewster
Woods Hole Science Aquarium
Bill and Ben's Chocolate Emporium,
 Falmouth
Cape Cod Museum of Natural History
Hallet's Store, Yarmouthport
Whydah Exhibit, Provincetown
Parnassus Books, Yarmouthport
Cape Cod Rail Trail
Mad Martha's, Edgartown

Pink lady's slipper

Quaint Villages

'Sconset, Nantucket
Gingerbread houses, Oak Bluffs
Woods Hole
Sandwich
Edgartown
Nantucket
Wellfleet
Chatham
Osterville
Harwich

Sunrise Spots

Fort Hill
Vineyard Haven
Nauset Beach
Edgartown
Head of the Meadow
Provincelands dunes
Bell's Neck
Sandy Neck

Wasque Reservation
Stage Harbor

Sunset Spots

First Encounter Beach
Little Island
Great Island Trail
Bennet's Neck
Pamet Harbor
Aquinnah
Madaket Beach
The Knob
Cape Cod Canal
Menemsha

Cranberry Bogs

MA 124, Harwich
John Parker Road, East Falmouth
Red Brook Farm
Green Briar Nature Center
Bourne Farm

Naushon Island from Aquinnah, Martha's Vineyard

Harbors

Menemsha Harbor
West Falmouth Harbor
Wychmere Harbor
Stage Harbor
Wellfleet Harbor
Chatham Fish Pier
MacMillan Wharf
Rock Harbor
Wild Harbor

Scenic Roads

Old King's Highway (MA 6A)
Sippewisset Road, Falmouth
Stage Harbor Road, Chatham
Sea View Avenue, Martha's Vineyard
Shore Road, Bourne
Old County Road, Wellfleet and Truro
South Road, Martha's Vineyard
Race Point Road, Provincetown
MA 124, Harwich

Most Published Images

Dinghies
Sailboats
Mussel shells
National Seashore beaches
Cape Cod Bay sunsets
Lighthouses
Footprints in sand
Shellfish farmers

My Personal Favorites

Great Island Trail
Menemsha Harbor
Wing's Island
'Sconset Village
Little Island
First Encounter Beach
Gingerbread houses
Woods Hole Village
Provincelands dunes
Thompson's Field

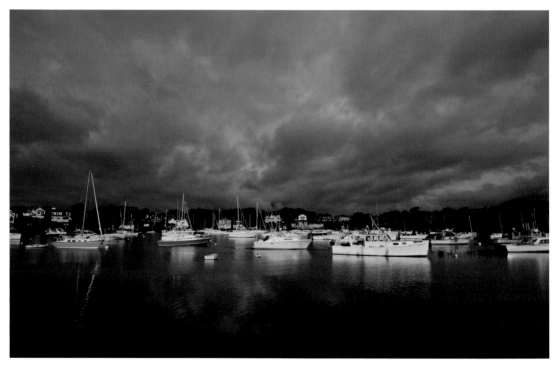

Wychmere Harbor